NORTH BRIGHTON
Preston, Withdean
& Patcham

THROUGH TIME

Anthony Beeson

AMBERLEY PUBLISHING

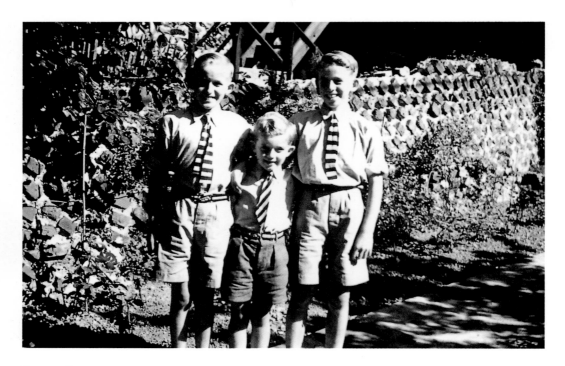

Preston Drove, 1954.

To the twins, Paul Jex Beeson and Hugh Marcus Beeson,
with love from their brother Anthony

First published 2013

Amberley Publishing
The Hill, Stroud, Gloucestershire, GL5 4EP
www.amberley-books.com

Copyright © Anthony Beeson, 2013

The right of Anthony Beeson to be identified as the
Author of this work has been asserted in accordance with
the Copyrights, Designs and Patents Act 1988.

ISBN 978 1 4456 1540 0 (print)
ISBN 978 1 4456 1563 9 (ebook)

British Library Cataloguing in Publication Data.
A catalogue record for this book is available from the
British Library.

Typesetting by Amberley Publishing.
Printed in Great Britain.

Introduction

'Preston, once a village with an independent life, is now Brighton', wrote Edward Verrall Lucas of the main subject of this volume in 1904. The same thing might also be said of Patcham and its hamlet of Withdean, who are the other protagonists within these covers. Lucas's statement was arguably less true in 1904 than it is now, when fields separated the villages from the ever-increasing spread of houses, although locals still speak of 'the village' in both Preston and Patcham.

The medieval parish of Preston stretched for roughly 2 miles from Hove to Hollingbury and was a mile in depth. Patcham was an irregular parish that spread up the coombes surrounding the source of the Wellesbourne stream. It reached as far as Hollingbury and Moulsecombe, bordering Preston to the south encompassing the manor of Withdean within its boundaries. All possessed good arable and grazing lands. Preston and Withdean were noted for their trees, the latter owing much to the plantations started or enhanced by William Roe from the 1790s.

The modern development of Preston and Withdean started with the houses of the Clermont estate, following the 1854 removal of the Preston turnpike. The later sale of Stanford and Curwen land for building opened the floodgates. Even now, after more than a century, the countryside is still just a few minutes away. The author Jeffrey Farnol, living near Carden Avenue in the 1920s, described himself as living in Sussex downland.

Preston and the northern suburbs of Brighton have always been dear to me. They were in many ways a new town of the 1880s to 1900s. Comfortable, tree-lined and well planned; housing all classes from the wealthy to the artisan. For those growing up in the area from the 1900s this newness meant that there was a great forging of friendships amongst the younger 'settlers' and everyone seemed to know everyone else. Fortunately now, conservation areas encompass much of the area covered by this volume, albeit tragically not in time to save the mansions of the Preston Road and many of Preston Park Avenue. In addition there are 'Friends of' groups protecting historic features within the area that the council can no longer adequately provide for. The areas of artisan housing between Surrenden and Ditchling Road seemingly still await protection.

Visually, one change in Preston, and indeed in much of Brighton over the last few decades, has been the whitening of rendered façades. Some were coloured from early times but most were not. Creeper clad was more often the favoured decoration. Jane Austen, complaining of

'the white glare of Bath' might certainly be blinded by twenty-first-century Brighton on a sunny day. On a wet winter's day it is certainly an improvement. Unfortunately, the whitening has also spread to brick buildings so the bright contrast between red brick and white paint that Edwardian architects so delighted in throughout the Preston area is here and there being lost.

Towns and suburbs are not just a collection of buildings but are brought to life by the stories of the people who once inhabited them. This book draws some of their names and ordinary deeds out of obscurity. My family had associations with Brighton from the 1870s and with Preston from the 1900s. For me Preston Park played a huge role in a happy childhood, as it did for most children in the area, and has done so since its opening in 1884. I recall family stories, such as an occasion in 1917 when my father and his brother used their baby sister's pram as part of a goalpost and went home after an enjoyable game only to be reminded by their mother that they had left their sister behind enjoying the park in the perambulator on her own. It was the place where one played boisterously, flew gliders, learned to ride a bicycle or fed the carp in the Rookery pond with bread crumbs. In contrast, one's home garden was for sitting, reading, and not annoying one's neighbours with noise or ball games. To see this wonderful park today is rather like meeting a once beautiful friend after many years and to find her sadly declined. The flower beds were everyone's pride, and the park's Floral Walk and Gardens of Greetings were seasonal delights. What Brightonian of those days could imagine a council in a premiere resort banning bedding plants for being 'environmentally unfriendly'? This does not criticise the gardeners, but more the age, as park's departments throughout the country have been similarly affected. In 2000, Brighton Parks Department employed 100 gardeners and Hove an equal number. They were merged and now only 100 manage both areas. Maximum effort is now concentrated on the Steine and Pavilion gardens at the expense of those inland. In addition, the ill-advised removal of fencing in parts of the city's open spaces has scarred once beautiful lawns with muddy tracks. Sometimes people do need controlling. However one might regret the change, parks of course, reflect the society that uses them, and if that society be informal and rough around the edges then I suppose so should its places of leisure be.

The many previously unpublished illustrations come from my collection of Brightoniana and from family albums. The selection has sometimes proved difficult. Indeed, so many historic pictures of scenes and events in Preston Park are in the collection that a book just dedicated to that might easily have been accomplished.

This volume is arranged geographically as a series of five textual peregrinations through Preston, Withdean and Patcham. One starts from the Preston viaduct while others commence from Preston Park Avenue, Preston Circus, Preston Village and Preston Park's Rose Garden. As both Preston and Patcham were large parishes, this first volume concentrates on the area surrounding the Wellesbourne Valley and Preston Drove. The forthcoming volume *North Brighton: London Road to Coldean Through Time*, will cover London, Ditchling and Dyke Roads together with Hollingbury and the Lewes Road.

My thanks to Clive Smith and Shona Milton, Brighton History Centre, and the anonymous Preston lady with pink hair of page 32!

Anthony Beeson

Walk One

'The One Pretty Road Out of Brighton'

By 1876, following the acquisition of Stanford land, the number of houses along the Preston Road had reached up to eighty-one and approached the southern side of the viaduct. The directory encouraged with the phrase 'and other houses building'. Soon, beyond this, the energetic Holloway Brothers would build not only Parkmore, their own residence at 103, but commence the line of large semi-detached and detached villas that became such a feature of this beautiful road. Their villas all shared the same design of gate piers. It is likely that the shared front garden wall was adapted from one of those erected by William Stanford along the entire length of Preston Road in 1817. Only one section still remains. From the 1960s a fateful change of use was encouraged for Preston Road. Hideous office blocks (some long derelict) have replaced villas and local roads are cluttered with the workers' parked vehicles.

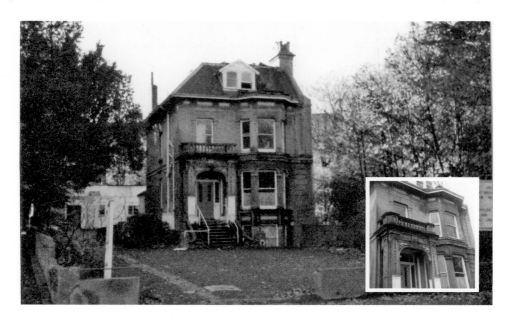

A Glimmering Lantern, 141 Preston Road

Originally called Denmark House, this was, in 1986, the last surviving example of the semi-detached mansions, built by the Holloway Brothers in the late 1870s, that had once graced this stately section of the road, now grotesquely marred by some of Brighton's least visually desirable architecture. Denmark's adjoining neighbour, Hatherly, had already fallen to the developer, but 141 survived until May 1986. It was acquired by the Brighton Society for the Welfare of the Blind in 1937, largely through the efforts of Miss Elizabeth Munro Ritchie. In 1932, she introduced the symbol of the Lantern, 'the lantern that lightens Brighton's blind', and the property became known by that name. It was opened in 1939 as offices and a successful social centre. In order to better finance its many services to the blind, the society reluctantly decided to sell the house in 1986. With its successor demolished the site completes the visual desolation of the area.

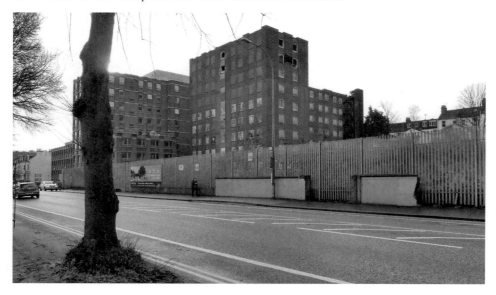

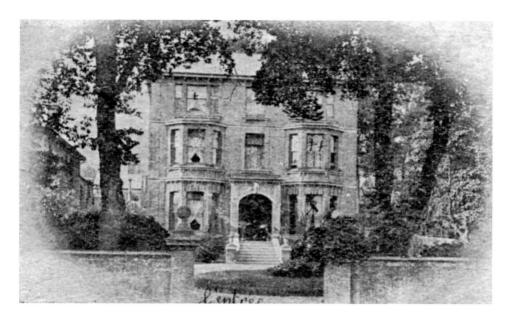

L'entrée to The Limes

The Limes at 157 Preston Road was another, particularly large, example of the Holloway Brothers' constructions of the 1870–80s. Looking rather like a huge doll-house, it had some fifteen rooms as well as other basement offices. As with the neighbouring properties, its spacious gardens stretched back almost to the railway embankment and contained both stables and a staff cottage. Between 1908 and 1916 it became the French School for Young Ladies under the Reverend Mother Sister Angeline. This postcard was sent around 1909 to France, and informs us that the front right-hand bay fronted a dormitory over the dining room. Marie, the writer, was sitting in her classroom at the top left-hand window. At the far left the chimneys of 155's conservatory and stables may be glimpsed. By 1921, 157 had become a hostel for the Eccentric Club. It was demolished in 1961 for yet another office block.

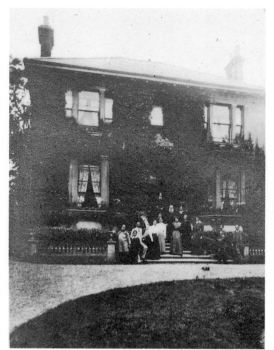

The Chinese Connection

Ferndale, 161 Preston Road, dated from around 1877. Its first resident was H. Stafford Smith. By 1913 it was the home of Philip Gek-Seng Low, his wife Mary Teo Low and their daughter Veronica T. S. M. Low. The images shown here come from a set of four postage-stamp-size photographs that show not only views of the outside of the flower and creeper-clad house, but also the dining room and drawing room (shown here). Those photographed on the house steps are mostly Chinese. Mr Low was a parishioner of St Mary's, Surrenden Road, and wintered annually in Nice. He would despatch boxes of carnations and mimosa every Easter to decorate the church; remarkably, these always arrived fresh. In 1922 he presented St Mary's with a jewelled monstrance that is still in use. Later occupied by the RAC, Ferndale remained externally intact until demolition in 1985 for the office block pictured with 157.

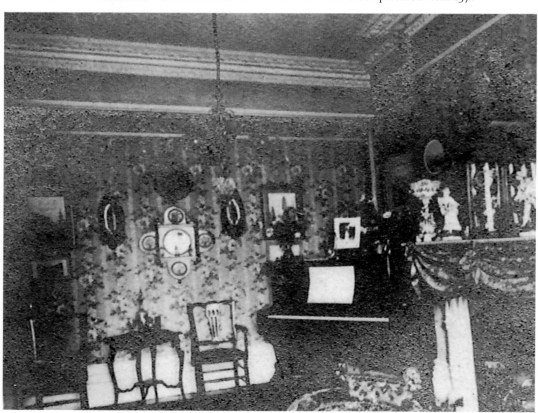

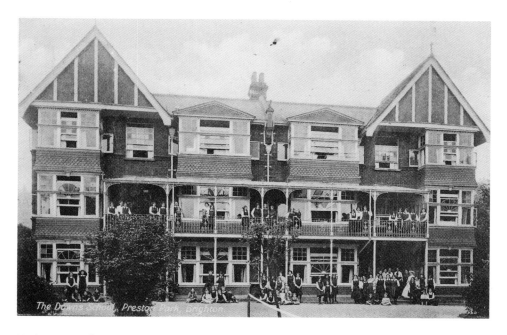

Welcome to the Downs School

This was originally built as two semi-detached and somewhat singular iron-balconied and tile-hung houses called Ashlyn and Parkside at 183–185 Preston Road. By 1907 they had become one building and housed The Downs School for girls under the principal, Miss Cooper. A 1912 advertisement acclaimed its twenty bedrooms, lofty classrooms, library, museum, studio and modern conveniences. Fees ranged between 15 and 22 guineas per term for girls from under twelve to over fifteen. It closed in the late 1930s. The building then became flats called Nestor Court. The fever of property speculation that resulted in the destruction of the Preston Road villas saw the building cleared of tenants by 1964 and left prey to vandalism and decay. By 1968 its deteriorating condition engendered an *Evening Argus* article delighting in the news that it was to be demolished. It was eventually replaced by the properties of Grange Close.

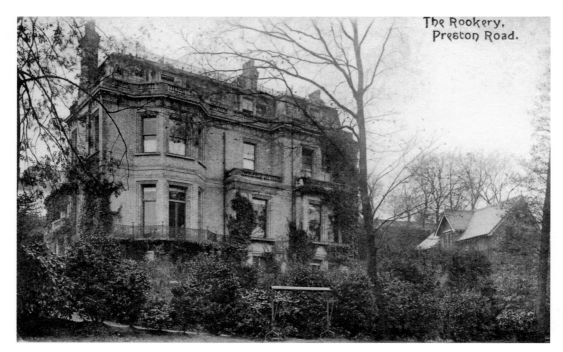

The Rookery,
Preston Road.

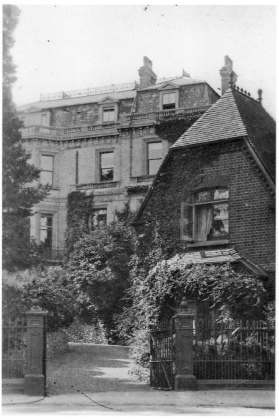

Stolid Luxury, The Rookery, Preston Road

Number 187 Preston Road was a huge, rather bleak, mansion of over twenty-two rooms, built of London stock brick on ground once covered by the old Preston Rookery that still adjoined it, and is now transformed into the largest municipal rock garden in England. Built by William Stroudley in 1880 and originally called Bosvigo, it was basically square in plan but with its bulk broken by bays, balconies and balustrades. The attic rooms had heavily pedimented windows and the mansard roof bore a railed cresting. A gardener's house stood close to the mansion and a lodge, seen below, guarded the drive. Stroudley's widow occupied it until about 1896 but by 1906 its occupier, Mrs Smitton, renamed it The Rookery. By 1914 it was the Rookery Hostel Training College for schoolteachers. It ended its days as flats and was demolished in 1963, being replaced by the houses and flats of Grange Close.

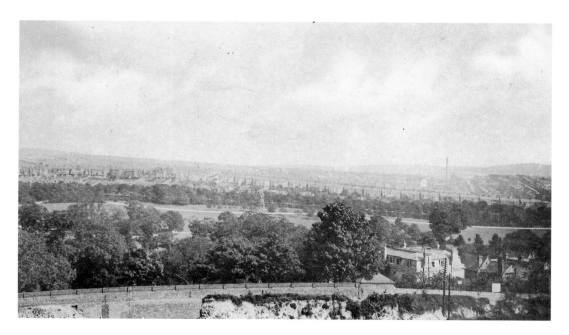

The Rookery and Park from Dyke Road Drive, 1911

The railway line and Preston Park looking towards the Ditchling Road and the Race Hill from Dyke Road Drive near the turning to Millers Road. The rear façades of the Rookery and the Downs School appear on the right-hand side of the photograph while beyond the park the roofs of the completed Preston Park Avenue and Beaconsfield Villas confirm the date. The tall chimney of the Corporation Dust Destructor appears in the distance above the Rookery. At this time a nursery called Rosslyn Gardens, run by the florist A. Prevett, occupied grounds and glasshouses, formerly part of the Rookery's gardens, in the vicinity of the square building on the rear boundary wall. Coincidentally a W. Prevett is listed as living in the Rookery Lodge and is presumably connected with this venture. Behind the wall in the foreground the Rookery rock garden was laid out in 1935.

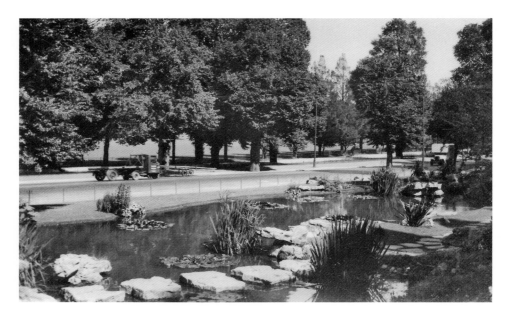

'To Preston's Green Grove'

William Stanford drove the rooks away from Preston Rookery in 1817 and they took up residence in the elms of New Road. Originally it connected with The Shaw, the celebrated elm grove situated near the present bowling club and then adjoining Preston's popular mid-eighteenth-century tea garden. Preston was noted for its profusion of trees: an antidote to Brighton's 'barren wastes'. The hurricane of 29 December 1836 caused devastation in Preston, felling thirty-seven great trees and a chimneystack at the manor. The Rookery was purchased together with the rest of the park in 1883, but left unchanged apart from laying out several bowling greens. In 1935 the park superintendent, Captain MacLaren, designed the spectacular Rookery rock garden, locally believed to be influenced by the willow pattern. It opened as shown in 1936. Vandalism and council cuts (now only one gardener tends it) have taken their toll. The pond was restored in 2013.

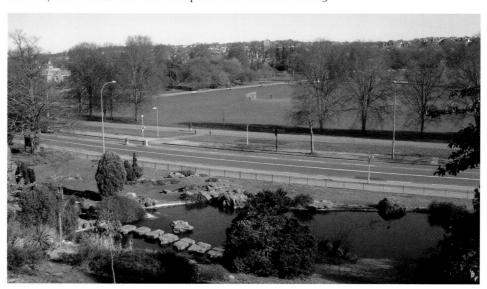

All the Turnpikes About Brighton Are 'Tuppence': Preston Turnpike, 1840

This notorious obstruction spanned the narrow Preston Road before its junction with South Road. On the right a double-arched brick bridge covers the ditch of the Wellesbourne stream and provides a pathway marked by whitewashed posts. In the distance the many chimneys of the Crown and Anchor, the first coaching inn outside of Brighton, appear. Left of it is the knapped flint Acacia House and the wooden building once part of Preston brewery and later the site of the Brewery Tap public house. The turnpike was in place by 1810 and hindered both Brighton visitors and Preston's development. Rather than pay the toll, visitors in carriages from Brighton would turn around or alight at The Shaw and walk to the village. After much agitation from Brighton and Preston, Parliament decreed in 1854 that the Turnpike Trustees should move the gate 100 yards beyond Withdean. The result was the development of Preston and Withdean.

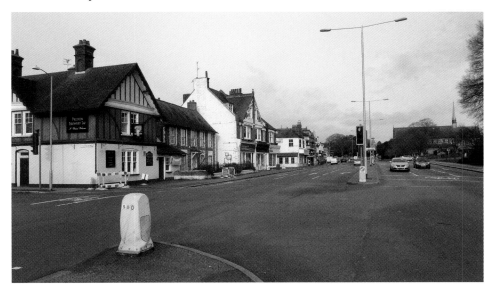

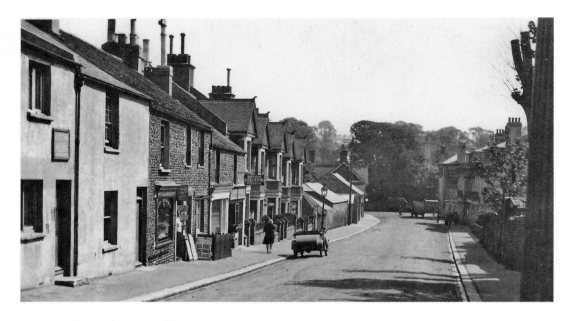

South Road, 1928 and 1986

South Road, looking towards the tower of St Peter's church and the Preston Road. On the left, the proprietress of Sayers general shop and newsagent's stands at her door watching the photographer, while a lady passes James Packham Jnr's garage, Archway Motor Works. Beyond a row of Edwardian villas, appear the pyramidically roofed malthouse and other ancient farm buildings of Preston Brewery and Dairies, alas demolished in 1994. Corralls, the wood and coal merchant, also had premises here behind the Brewery Tap and the Preston Road. To the right the wall encloses the buildings of the former Manor Farm, including that pioneer of cinematographic equipment, Alfred Darling's mechanical engineers. In the 1920s a small private school run by Robert Ibbs operated for a while in part of the handsome Georgian farmhouse, then called Ye Olde Cottage. The elegant Stanford estate offices and the now demolished Black Lion close the scene.

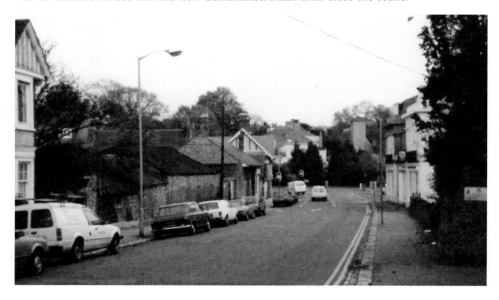

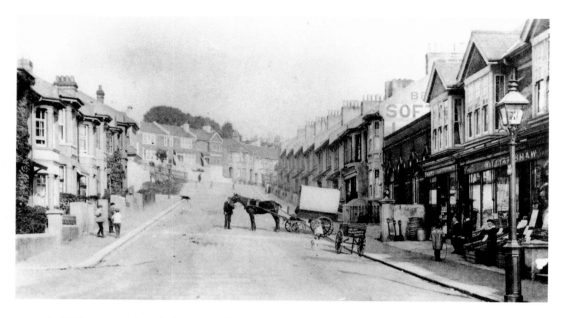

Soft Water and Rough Boys in Robertson Road

Robertson Road developed from 1885. It lay with its adjacent streets west of the great railway embankment that isolated it from the village proper and, consequentially, seems to have formed its own community. An arch, piercing the embankment, joined it to Preston's South Road. This almost self-sufficient development included shops for most needs, including the grocer-cum-ironmonger William Shaw's substantial establishment, and his pushcart rests outside. Adjoining it, and adjacent to the delivery wagon in the photograph, was the arched façade of the Brighton Soft Water Laundry, an employer of many women. In the 1960s this became the Southdown Hamper and Basket Works. Robertson Road had a bad reputation in the early decades of the last century among its more affluent neighbours. The author heard many years ago from independent sources that respectable parents feared the influence that association with 'rough boys from Robertson Road' would have on their own progeny.

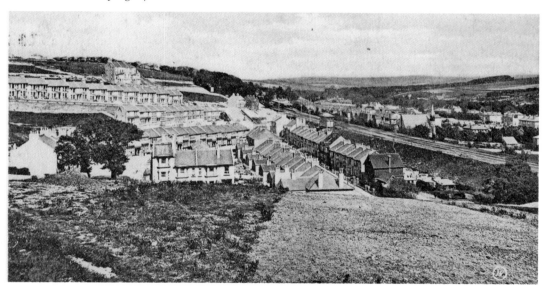

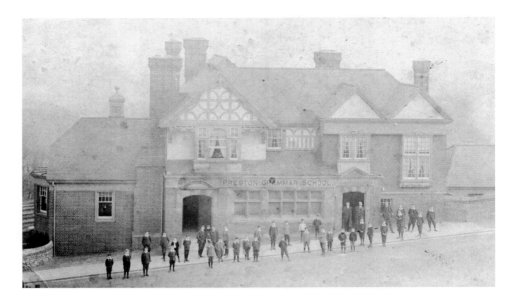

Preston Grammar School on Display, 1907 and 1911

The boys and masters of Preston Grammar School, at the bottom of Millers Road, photographed in 1907 outside of their smart new Arts and Crafts building. This interesting structure dates from 1899 and was terraced into the hillside on the wedge-shaped site overlooking the railway. Originally, the legend 'Preston Grammar School' was cut into the frieze above the ground-floor windows. The headmaster of this private school, which took both boarders and day pupils, was A. W. Parvin. From the 1950s to 1970 the building housed the pupils of the wonderful, theatrically named, Dodo Jaye School of Dancing but, following dereliction, it was turned into flats. Adjoining the school are Millers Road's oldest houses. Later road construction buried the original slope of their front gardens for, originally, the route continued down the existing back lane. The present late nineteenth-century diverted course of Millers Road from here crosses a filled-in chalk pit.

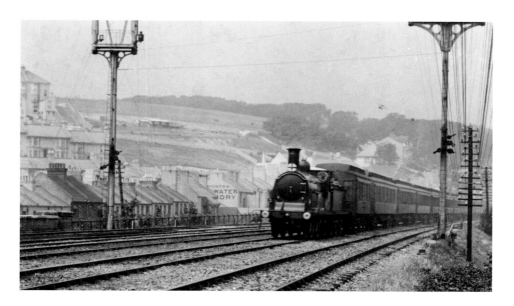

Under Development; Jacob's Ladder

A Stroudley 0-4-2 'Gladstone' class engine passes Robertson Road around 1904. William Stroudley, its designer, was the owner of Preston Road's *Bosvigo* (The Rookery) and one of Britain's foremost steam locomotive engineers. The moderniser of Brighton railway works, he died at the Paris Exhibition of 1889 while exhibiting. Woodside Avenue climbs to Tivoli Copse on the right while cattle graze on the yet undeveloped hillside above. On the left, the houses of Kingsley and Hampstead Roads appear and the backs of the three isolated houses in Tivoli Crescent, all that was achieved of that development. By their side descends the great flight of steps cut into the hillside to provide access to the village. When the author was a child, these were occasionally referred to as 'Jacob's Ladder'. No doubt their building was to tempt more people to live on the spectacular but inconvenient heights of Tivoli Crescent. In this they originally failed.

'Preston Village, Near Brighton, 1830'

An early drawing of Preston village from the author's collection: the valley's trees somewhat obfuscate identification but a south-west prospect, from the precursor of Miller's Road seems likely. The church tower appears amid trees immediately to the left of and above the leaf spray of the tree trunk on the right. Buildings in South Road dominate the foreground, backed by the impressive roofs of those facing Preston Road. The isolated building on the right may be the Preston Turnpike. The lower photograph shows probably the same view around 1895. The railway now appears in the foreground, on the bare hills, Surrenden Road, Beaconsfield Villas and Preston Drove appear as white scars devoid of houses, although trees line the lower Drove. A lone house (Helvellyn) appears to the left, on the south side of Harrington Road; Harrington Court flats has now replaced it. The southern hedge of the vicarage's glebe stretches to its left.

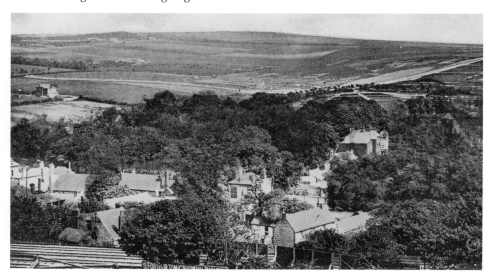

Of Cottages and Palms

A charmingly picturesque jumble of flint and brick vernacular architecture once stood at the top of Middle Road. Much admired, if possibly verminous, they were further enhanced by the surprising presence of a large Chusan palm tree in the tiny front garden of No. 38. This was possibly Brighton's smallest house. In those days only the Royal Pavilion grounds boasted such palms and the unusual juxtaposition of an exotic plant with such a small, unlikely house made the tree locally famous. Photographed in 1968, the cottages were demolished in February 1969 for a new development. The palm survived isolated in situ for fourteen months (see next page) and local people assumed that it would remain in the new development. However, the developers sold it to South Coast Nurseries (Standen Brothers Ltd) of Ditchling who intended to use it as their trademark. It was moved in June 1970.

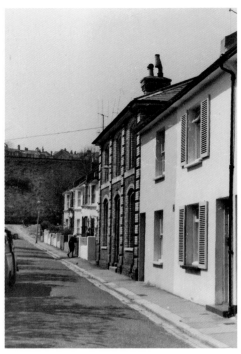

'There Was Always a Policeman on the Corner or Riding His Bike'

Preston had a district police station by 1871 although Philip Lockwood's brick building at 18 Middle Road (photographed 1969) dates from 1882. It combined both police and fire station as, in 1881, the Police Fire Brigade had been formed and continued in operation until 1921, when the County Borough Fire Brigade superseded it. The great red, wooden gates opened into North Road and remained until domestic conversion altered the façade mid-1960s (photographed 1972). In 1928, call boxes replaced most district police stations. One stood on Preston Road opposite the park entrance. In 1918, a report reached my grandfather that young Cyril Beeson had been associating with several rough boys from Robertson Road. Fearful of a future life devoted to crime, he arranged for his friend, the superintendent, to show the boy the cells as a warning. A miscalculation, alas, for Cyril found the whole episode thrilling and tried each bed in turn.

Preston Village School, North Road, 1971

Preston Church of England School in North Road was built in 1850 by Squire William Stanford on land donated by George Harrington. It is a simple yet attractive building with gothic windows and ornamental bargeboards. Its brown and cream façade had 'Preston Infants, Est. 1850' over its east window. Notwithstanding its cramped position, it lasted until 1959, although for much of the century in competition with more modern local schools. After 1959 it became a school for disabled children and later a Barclay sheltered workshop for the blind. It is now housing. Many parents, like Herbert and Ellen Beeson, preferred to send their children to the modern Preston Road Board School next to the viaduct, although my father, John, being considered 'delicate', spent his infancy at Miss Tupper's Kingsthorpe in Preston Drove. Even in 1971 North Road still maintained a country atmosphere. The long flint wall on the right originally bounded the garden of the Crown and Anchor.

Potter's Forge and North Road Cottages

Cottages in North Road await demolition in November 1968 in the same redevelopment that removed those of Middle Road and its community. Beyond them, No. 29, the green-and-white building adjoining the flint cottages, was originally a stable, and then a taxi garage and finally a milk bottle washing factory. It is now a house. The original village smithy had succumbed to the railway embankment and was removed to North Road. There, unless occupying an existing carriage house, it was strangely placed in the formal garden of the elegant property now called Garden Cottage. It had twin-furnace flues and double doors opening on to the street. W. Potter was the smith there in the early 1930s, and it is reported that he would happily mend children's Fairy cycles. Later Ernest Johnstone built miniature coaches there. It finally became a garage (photographed in 1986), but burned down, and has been rebuilt as a house.

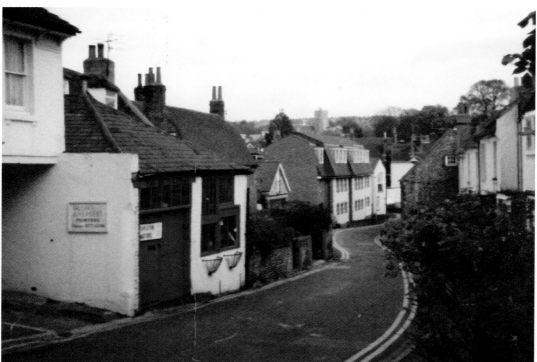

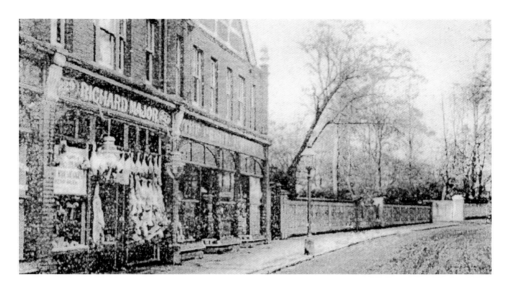

'By Appointment', 229 Preston Road

Major's butcher's shop in 1907, shortly before becoming Brampton's and the installation of a tall wooden coat of arms with the legend 'By appointment to his Majesty' between the windows. Coachmen of equipages would salute this by blowing their horns in recognition. Orders for meat were placed weekly by the manor housekeeper, who would arrive in a carriage. In this large shop Herbert Jex and Ellen Beeson managed a staff of six and the bookkeeper, Miss Mason. The attached house had nine rooms, a kitchen and large scullery with a copper. The spacious front rooms overlooked the vicarage gardens while a large meat cellar was accessed from just inside the front door. Herbert managed the shop from 1906 until his retirement in 1932 at a salary of £10 a month together with the house and other perks. Villagers join John and Herbert (first and second left, back row) and Ellen (middle row, second left) at 229 in 1925.

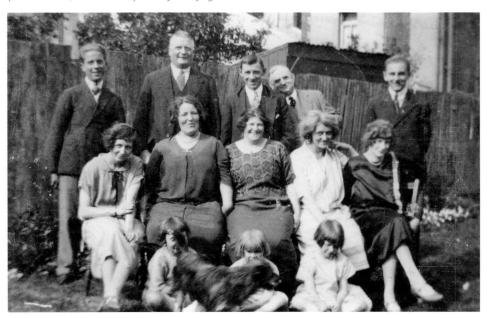

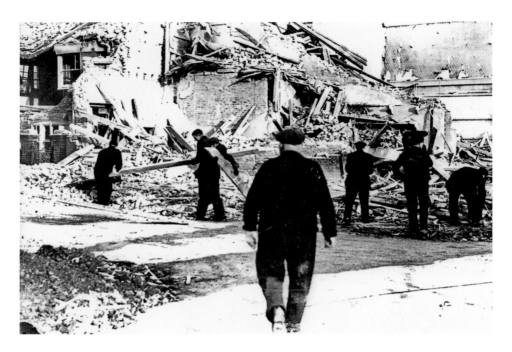

'They Bombed Our Butcher's', 229 at War

Civil defence workers clear rubble from the corner of Lauriston and Preston Roads following the disastrous air raid of 9 March 1941 that, apart from wreaking havoc elsewhere in the village, destroyed numbers 227–231 Preston Road. Hole's and Davigdor Dairies, Colbourne's Butchers (formerly Brampton's), The Preston Stores and a house in Lauriston Road were destroyed. In addition, Brittain's Garage at 233 and Gravely's Grocery shop at 225 suffered extensive damage. Young Bernard Colbourne sadly died in the devastation. Nissen huts were erected on the cleared site and in 1951 a smart extension to Britain's garage was constructed. Under various owners, the site remained a garage until recently, when the building became a Sainsbury's supermarket. One of the distinctive brick piers from the destroyed house in Lauriston Road remains as a memorial to this event. This lost shopping parade of 1894, like the two remaining, was designed by Charles Stanley Peach.

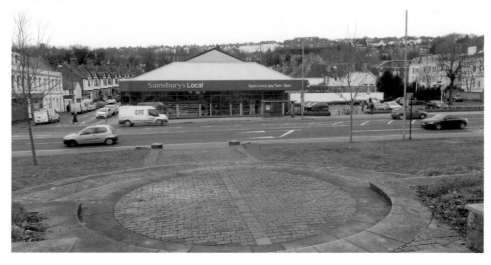

A Lost Vicarage and Eight Stolen Tripods

Preston vicarage was double-gabled, probably Georgian, and stood in extensive grounds adjacent to Preston Road. It appears in J. Cordwell's watercolour of Preston Village in the 1840s in the Brighton Art Gallery. Seen here from the north, by 1900 it had been extended and modernised, with the double gables infilled with staff bedrooms, giving the roof a gambrel appearance. Its size was its undoing, as by 1930 it was too big for any prospective vicar to take on, and so was sold to the Corporation who laid out the Vicarage Bowling Greens on the site. The elegant 1930s brick pavilion shown here in June 1987 and its pair in Preston Park had Neptune masks and four magnificent bronzed tripods, much beloved by the author as a child. Alas all have been stolen in recent years. The photograph also shows the scar on the side of St John's where its apsidal chapel should have gone.

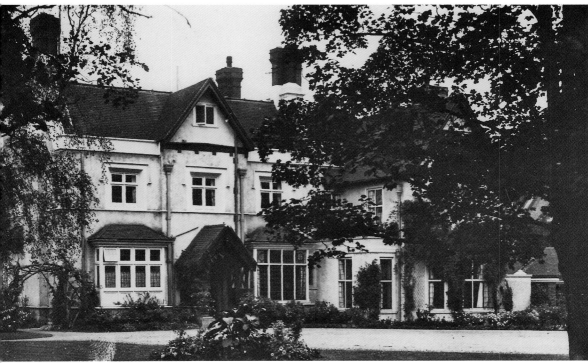

25

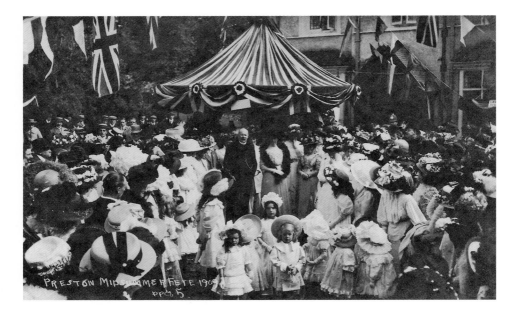

Miss Poppea Peacock Entertains

The annual highlight of the Prestonian social scene was the Preston Midsummer Fete, a two- or sometimes three-day spectacular that took place in the beautiful and extensive vicarage gardens. Originally designed to pay off the debts accrued from building St John The Evangelist, the first fete took place on 28–29 June 1899. Organised by the parish's artistic and social elite, by 1912 they were attracting around 1,000 visitors each day. Apart from the recitations given by Poppea Peacock's pupils, delights included stalls, floral cars and processions, fairy dancing, the Norwegian Café musical (which featured Mrs Thomas Stanford), the Beech Tree Café, glees, bands, the Crystal Palace Artistes, evening illuminations (by Messrs Stead) and the rose garden itself. The fetes were ended by the sale of the vicarage in 1930. They were revived between 1976 and 1999 and augmented between 1948 and 1998 by the December Preston Fayre, held in the Knoyle Hall.

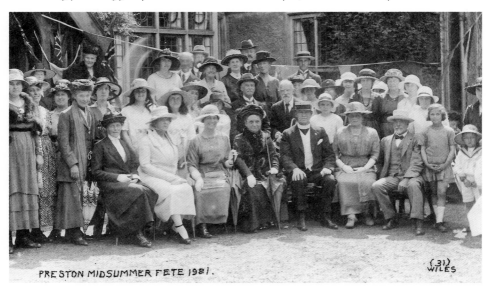

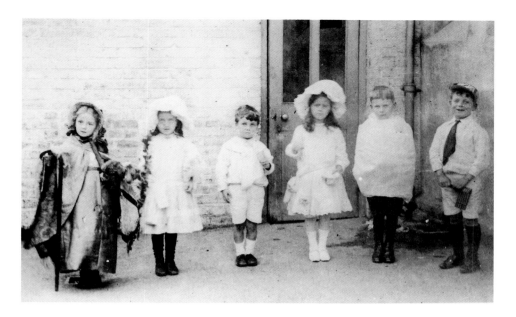

The Children's Pageant; Young Prestonians Prepare...

Cyril Beeson (far right) with a wooden rattle, Little Bow Peep and other local children prepare for the annual Children's Pageant 'kindly arranged by Miss Egerton-Welch, specialist in Society Novelties for the Ballroom and Mattclinche Presilieune', for the Preston Midsummer Fete that was held on the vicarage tennis court, 'approached by the Monk's Walk'. Those not entirely fulfilled by the pageant could compensate by viewing the vicar's adjacent rock garden. Its rose garden was acclaimed as one of the sights of Preston. On the vicarage drive, ladies staffed stalls selling flowers, greengrocery and dairy products. Postcards of the fete were available within hours of photographing. Punch and Judy shows given by Professor Gale 'leading exponent of the Fantocini art' were given twice daily at the 1913 Fete. Prospective attendees at performances were assured of 'the entire absence of anything the most sensitive or fastidious person could object to'.

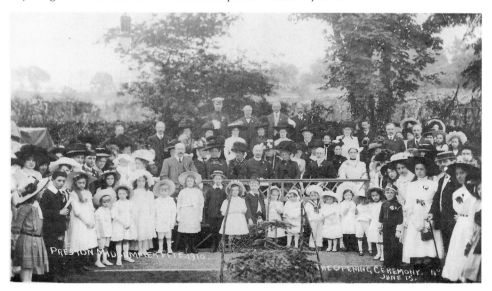

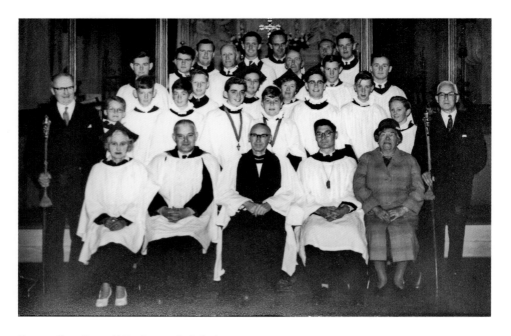

Farewell to Russell Taylor at St John's

September 1962 saw the retirement of Russell Taylor, organist and choirmaster (second from the left front row). He sits next to the Revd Riddle Raper. The author, as head chorister, is between them and next to Huntley Russell Taylor, second chorister. Under Taylor, the church's Christmas Nine Lessons and Carols became famous. St John The Evangelist was designed by Arthur Blomfield in 1901 and built on a considerable scale to accommodate Preston's rapidly expanding population that had outgrown St Peter's. At first funds permitted only the construction of the nave as shown. The chancel was added in 1926. A fine Thorvaldsen-inspired font and stone reredos were added by 1908. Unfortunately, the apsidal side chapel at the south-east corner that would have added so much aesthetically to the church was never constructed, and shows as a scar of brick on the exterior. The church today remains a vibrant and popular place of worship.

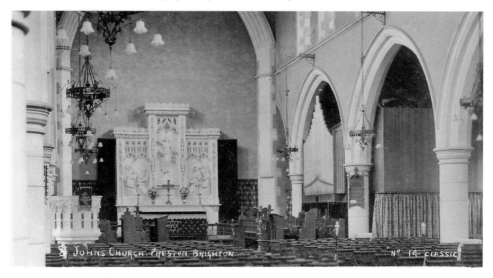

Knoyle Road from Queen Mary's Villas

St John's displays the east end of its nave and the arch that would eventually lead to the chancel when funds permitted this to be built in 1925/26. Below the flèche, on this wall was a wooden bell canopy. The corrugated iron church hall, built on the site of the projected chancel in 1902, only cost £400. W. B. Taylor, who was then building the houses on the north side of Knoyle Road (finished 1904), laid out the hall's foundations as a gift. Beyond the church, villas on both sides of the Preston Road appear, and behind them the spaced blocks of Lorne Villas. The hillside is scarred with freshly cut Woodside Avenue sporting its new houses and the Station Hotel. Queen Mary's Villas was not developed until the 1930s, but was renamed Bavant Road in 1921. Harry B. Nixon developed Knoyle Road's later houses in the late 1920s. The 2013 photograph reverses the view.

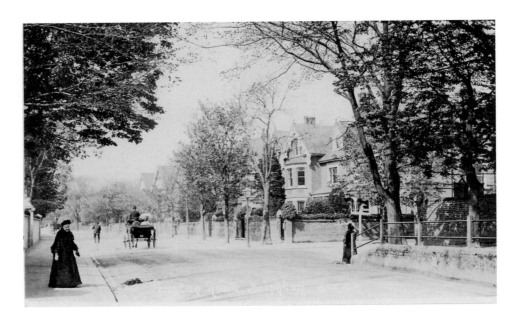

The Villas in the Garden

A view of Preston Road, looking northwards around 1907. Knoyle Road is on the right by the side of the new parish church and the row of villas at 202–214 dating from the early 1890s that continue to the start of Harrington Road. The tree-lined and picturesque raised walkway to the right was lost to road widening. Originally the vicarage's circular entrance drive, formal and kitchen gardens stretched in a wide band along this road and up what is now Harrington Road as far as Bavant Road. This was the Glebe or the land set aside to support a parish priest. When this was developed, the vicarage gardens at the bottom of Preston Drove were expanded eastwards over allotments. Knoyle Road, like others locally, was named after Stanford possessions in Wiltshire. Shirley, 206 Preston Road, remains a beautiful example of the Preston villas and even retains its wooden sunblind boxheads.

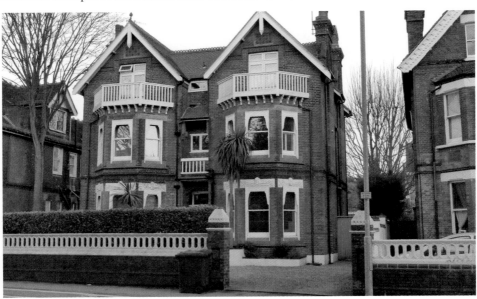

The Last of Stamford Lodge

By 1882 Cumberland Road had been laid out and contained three large detached villas. On the southern side was Clermont, the extensive gardens of which stretched down to Preston Road, while on the north were Cumberland Lodge, Stamford Lodge and (facing Preston Road) Belgrave House. Probably built in the late 1860s and certainly in existence by 1873, Stamford Lodge was a handsome, many gabled, and slightly Germanic-looking house with oriel windows and elaborate pierced bargeboards. It was gently decorated with somewhat eclectic medieval architectural embellishments. A wooden porch with a high-pitched sloping roof rested between two wings and sheltered the front door. The house was unfortunately demolished in the summer of 1969 and replaced with flats that perpetuate its name.

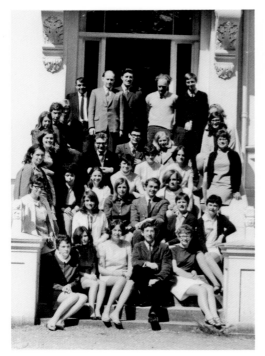

A Stack of Librarians at 251 and the Kindness of Strangers

Brighton School of Librarianship was a satellite of Brighton College of Technology in Lewes Road, and was one of several such colleges and universities throughout the country where students could train to become professionally qualified Associate Members of the Library Association. For some years it occupied 'St Helen's', the 1870s detached villa at 251 Preston Road, later occupied by the Clermont Child Protection unit. The group photograph, taken on the front steps, shows the students of 1967 in their final week at the college in the summer of 1969. When the college finally moved, the new occupants joined St Helens unaesthetically with its neighbour, Battlesden. Both houses now await tenants. The modern photograph was kindly taken by a young local woman who, on seeing the author attempting to take one from the pavement, and hindered by the garden's foliage, offered to scale the wall and assist him. She did just that!

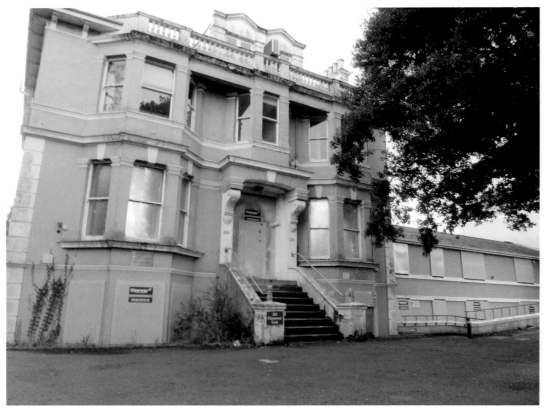

Westdean to Hollingbury in 1908

A view from above Tivoli Copse, looking towards the wooded estate of Hollingbury Court high on the Ditchling Road. It shows the first great houses of Surrenden Road above the roofs of Shalimar and Tower House in the foreground. The roof of Withdean Lodge in the mid foreground is topped by the walls framing Varndean Road, the original access to Mount Harry. This was the first house constructed in that area and predated Surrenden Road. The new scar of Cornwall Gardens crosses the centre of the picture. At the upper left spreads Fairlie Place, the publisher Emile Moreau's huge and beautiful new residence, with its adjacent staff house. Built in 1906 and set in extensive gardens that sloped down towards the London Road, it escaped developers until 1968. To the right of Fairlie stand Maycroft, Ardshiel, Varndean, Surrenden, Mount Harry and Woodlands. All are now demolished or, like Varndean and Surrenden, renamed.

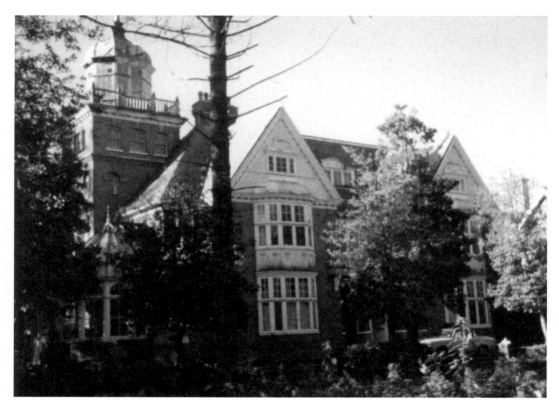

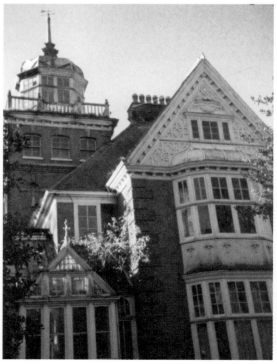

In Search of a Prospect, Tower House
When the jeweller, John Savage, retired to Withdean in 1902 he commissioned Burstow and Sons to erect the house seen here in 1986. The sloping 2-acre site had been part of the eastern grounds of the Tivoli Tea Gardens and lacked elevation, being backed by the railway embankment and Tivoli Copse. Savage therefore requested a viewing tower to afford prospects above the trees of the valley. The result was a beautiful Edwardian house, boasting under-floor heating, a conservatory and an entrance hall with a great dividing staircase, illuminated from above through stained glass. Over its ogee half-domes the gables were decorated with elaborate strapwork pargetting, originally unpainted apart from above the attic windows. Savage's monogram and the date 1902 adorned a central cartouche. The interior was, alas, partly gutted in a new development in 1988, but the façade was, nevertheless, restored as a feature of the estate.

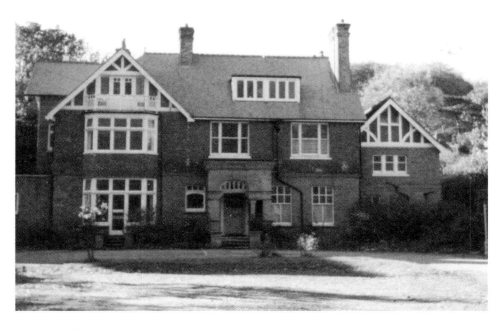

'By the Shalimar', the Last Days of Tivoli

267 London Road as it was on 8 November 1986. Originally called Shalimar, it was built for W. R. Hawkins by W. B. Taylor in 1903 to the designs of E. J. Hamilton. It again stood on land once occupied by the Tivoli Tea Gardens and almost abutted Tower House. Taylor also built fifteen large residences in nearby Harrington and Knoyle Roads as well as the Preston Stores in the village. His later work included 24 Cornwall Gardens that was built as a wedding present for his daughter Henrietta to Herbert Bolingbroke in 1906. In the 1920s Shalimar was renamed Tivoli and then bought by the wealthy baker Thomas Price, who lived there until its compulsory purchase by Brighton Council, who turned it into a Welfare Services Residential Home. By 1986 it was empty and for sale. It shared the fate of many of its neighbours and was demolished in 1988 to be replaced by Tower Gate flats.

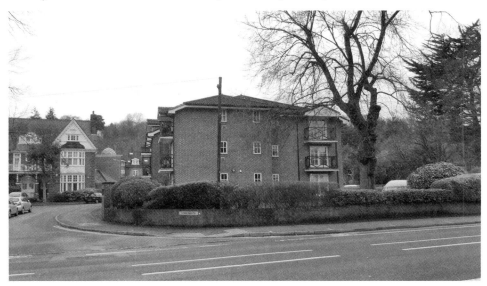

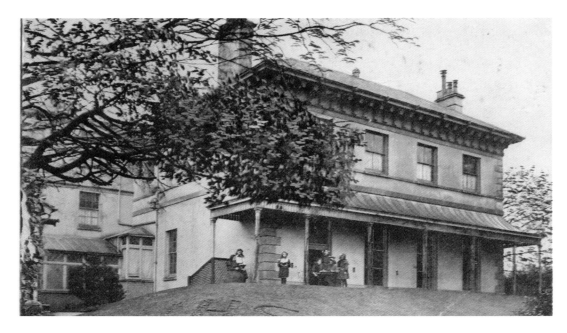

The Other St John's

Around 1851 four detached Italianate villas by the same architect rose east of London Road opposite Tivoli Gardens. They shared certain peculiarities such as being raised on grassy terraces. Woodslee, the earliest, was the most elaborate. Its façade was rusticated, and above its canopied veranda the elaborate entablature had gutters with lion masks surmounted by antefixes. Its terrace was stone clad with central steps. Its plain southern neighbour, St John's Hall was, by 1861, a ladies' seminary. Purchased by the Sisters of Nevers around 1903, it became Lourdes Convent. The western façade appears above. The half-timbered iron chapel stood to the left of the viewer and also appears below. J. S. Gilbert's grand replacement rose in 1938. By the 1920s Woodslee was purchased, becoming the School House. Stripped of decoration and architecturally destroyed by the addition of another storey it appears at the left of the lower photograph. Lourdes Convent was demolished for Kingsmere flats in 1972.

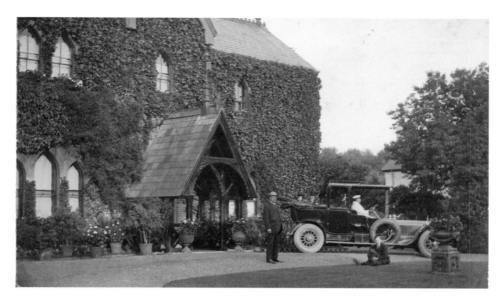

'This is Grandmama's House'; The Jerrard Family Take a Spin

Laine House was one of three mansions built in the late 1850s to early 1860s on the east side of London Road at Withdean. The Gothic, brick-built house featured pointed stone windows, a high pitched porch, inscribed with 'Where there's heart room, there's house room' and ornamented with a dragon finial and vane, and an elaborately timbered gable. The photograph was sent in 1916 by Betty, the granddaughter of the then occupier Thomas Webber Jerrard (1843–1931). The three properties were purchased piecemeal by Brighton Corporation between 1956 and 1972 and sold to developers who demolished them. Laine Close now commemorates the house. The Preston Society secured the survival of the trees on the site. Withdean was noted for its trees, many of which were planted by its proprietor William Roe from 1794. On 9 November 1800 a tremendous north-westerly gale destroyed fifteen ancient elms in Withdean's valleys and more in Preston.

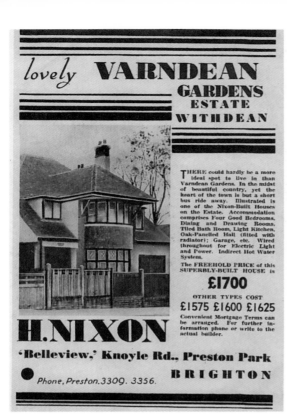

'Lovely Varndean Gardens ... Withdean'

'In the midst of beautiful country, yet the heart of the town is but a short bus ride away,' reads a handbill for Henry B. Nixon's new estate in the grounds of Withdeane Hall, which by this time had become a boys' school. The first house constructed was in 1932 and Nixon's estate office was also on site. His deluxe 'Nixon-Built Houses' sold for £1,700 and boasted 'Four good bedrooms, dining and drawing rooms. Tiled Bath Room, Light Kitchen, Oak-Panelled Hall (fitted with radiator), Garage, etc.' Other types cost £1,575, £1,600 and £1,625 respectively. Nixon's own house was Belleview in Knoyle Road, and he was probably the builder responsible for the rest of the 1920s and '30s houses in the surrounding roads. Withdeane Hall of 1861 itself survives but the natural polychrome of its flint and brick western façade was spoiled during conversion to flats in the 1950s.

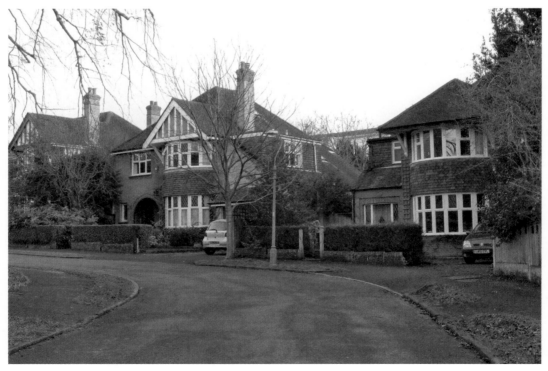

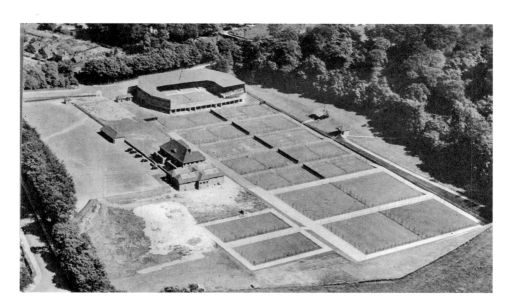

'Doesn't Brighton like Tennis?'

On 17 April 1937, the Sussex County Lawn Tennis Ground opened at Withdean. Built by the Corporation on former playing fields at a cost of £40,000, it included ten grass courts with undergound irrigation, eleven hard courts and four squash courts. Sunday matches were permitted. According to the official guide, the now demolished centre court grandstand could accommodate, 4,100 spectators, while 'delightfully planned' club premises catered for members needs. Hailed as 'the new Wimbledon', it nevertheless did not attract great numbers of spectators to its first international tournaments. During the war it became a mortuary but it was relaunched in 1947 as Brighton Olympic Stadium ('the Wembley of the South') with the later zoo surrounding the courts. Redeveloped for athletics, with new grandstands and a running track, in 1955 it reopened as the multipurpose Brighton Sports Arena. Decades of expansion followed and, from 1999 until 2011, it became Brighton and Hove Albion's home ground.

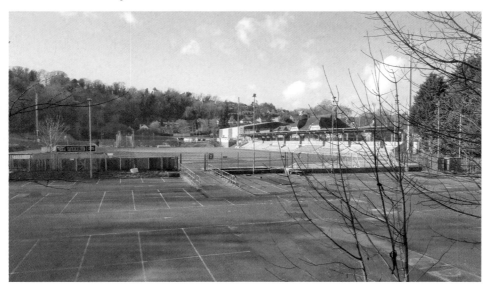

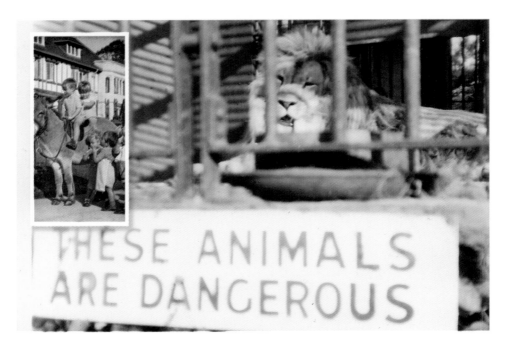

'These Animals are Dangerous'; In Search of a Real Elephant

Jean Simmons opened Withdean Zoological Gardens at Brighton Olympic Stadium in 1948. They boasted a model farm, pets corner, a 'children's paradise', model and miniature railways and a tea garden and cafeteria for refreshment. Animals included apes, lion, tiger and bear as well as dingoes, llama, goat and wallabies. Their cages might raise concern today and there were several escapes. There was a craze for mechanical walking 'robot' elephants and several were made for zoos and seaside resorts by Maurice Radburn and Frank Stuart. Withdean had one and I rode on it. My mother took me to Withdean on an afternoon walk when I was three in 1951. There were seats either side of Jumbo's back for children and it had a male 'keeper' who guided it. I recall wishing at the time that it had been a real elephant like at London Zoo. Withdean Zoo closed in 1952.

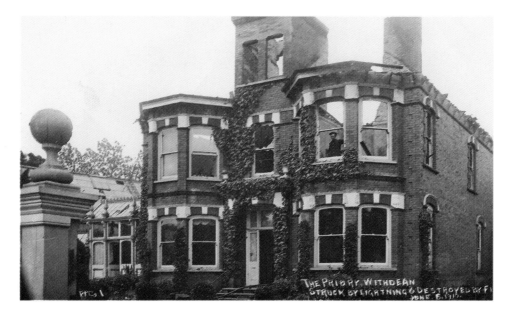

The Wrath of Zeus on the London Road

The Priory was a brick-built, double-fronted villa of 1882 with white-painted details and a central tower. It clasped an elaborate conservatory and a huge palm-house to its southern side and stood opposite the end of what is now Carden Avenue, and just south of its neighbour Sunnyside. Its frontage was separated from the London Road by an elaborate, ball-topped and painted wood and iron fence. The original owners were David and Emily Lade but the former had died in 1898. On 6 June 1910 the house was struck by lightning and seriously damaged in the subsequent fire. The Press Photo Company of Havelock Road immediately issued a set of postcards of the event and these were being sent by 9 June. Mrs Lade had the property restored, but Miss Wright was the listed occupant by 1911. The Priory was demolished for the flats that commemorate its name in the 1970s.

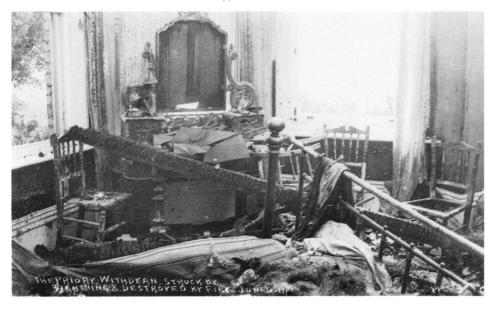

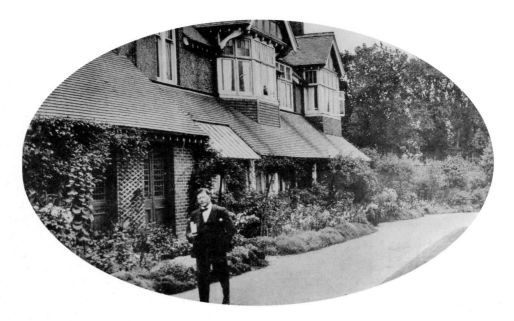

'A Large and Well Planned Residence', Sunnyside, Patcham

Sunnyside was fairly new when, around 1910, it attracted the attention of the popular romantic novelist Jeffery Farnol, fleeing from his Lee residence on account of the constant noise from a new tramline. The house was south-facing and sheltered from the London Road that ran beyond the trees at the right of the picture. Farnol's brother recalled that everyone liked the house especially Jeffery's American-born wife Blanche. The photograph showing the forty-four-year-old author outside the house featured in the *Graphic* of 23 September 1922. Farnol divorced Blanche in 1938 and went to live in Eastbourne with a new wife. Blanche (1884–1955) is buried in Patcham churchyard along with her mother and father the notable architectural watercolourist, Hughson Hawley. Later renamed Homeleigh, the house was replaced by an estate of that name. Only the front wall and blocked gateway now remains of Sunnyside.

The Garden of Peace

The cutting of the Patcham Bypass in 1926 left a kite-shaped piece of land between the course of the old and new London Roads. The southern end of the site was developed in 1929 as a small park, comprising a northern grassed recreation ground and a southern ornamental garden dedicated to Peace. A raised walkway surrounded a sunken garden with a central polygonal pool. Two Tuscan colonnades, with columns sourced from the same supplier as the Preston's Rose Garden, stood on the northern walkway. Between them was a small temple or pavilion for contemplation. Unlike the Rotunda of Preston Park, there can be no doubt that this structure is of reused ornamental stone purchased from the British Empire Exhibition of 1924/25. Urns from the Aquarium were used here and possibly (at first) statues from the Victoria Gardens plinths. Long neglected, the garden is now the focus of a local volunteer group.

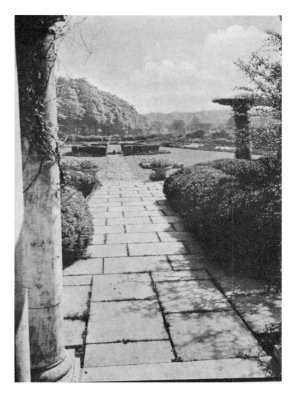

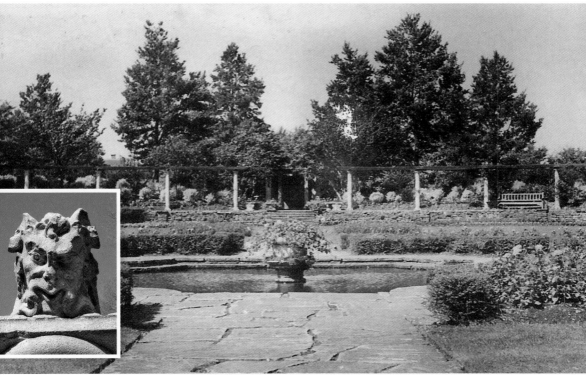

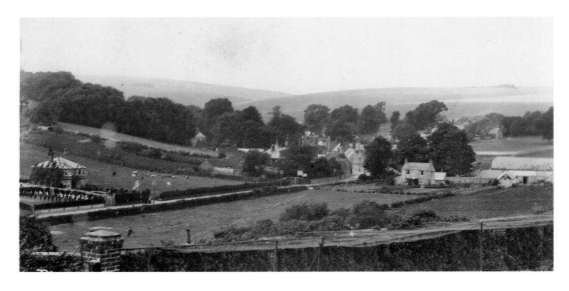

From East to West and Back Again, 1910

A view towards Patcham village from the gardens of Ashburnham, across the valley of the Wellesbourne and the Old London Road. To the left the segregated rows of boys and girls of Patcham National School extend their arms during physical exercises. Beyond them the poplars bend in the southerly wind over Meadowside's slated roof. The meadow beyond, not yet scarred by the 1926 bypass, has poultry coups and several horses. The curve of the village follows the road to the left while the gables of Church Hill appear to the right. The view from the opposite side of the valley shows the rear of Meadowside and the school on the left and Ashburnham and Patcham Grange in their walled gardens, on the hillside above the road. Above Ashburnham isolated cottages stand at what would become the corner of Braybon Avenue and Greenfield Crescent. Hollingbury's woods crown the hillside.

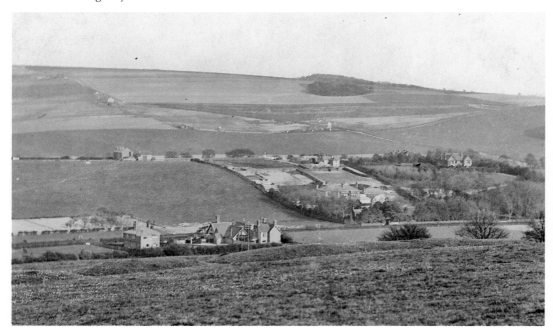

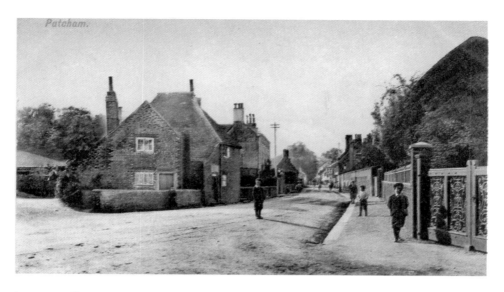

'A Dusty Village' on the London Road

An evening view, looking north through Patcham village from the junction with Ladies' Mile Road and along what is now the Old London Road that, before the building of the Patcham bypass, had to cater for all north–south traffic. The card was sent in August 1905. On the right the elaborate cast-iron panelled gates of Wootton House are dominated by a huge clipped yew that still survives in a natural state. At a later date the corner was cut back and the wall rebuilt in a curve. This handsome villa was the home of Miss Tanner. Its façade appears to be of glazed black brick rather than the mathematical tiles used at Patcham Place. A row of neo-Georgian houses now occupy Wootton's northern gardens. The old Black Lion inn appears beyond. On the left may be seen Southdown House Major Howard Vyse Welch's fine knapped flint-fronted property.

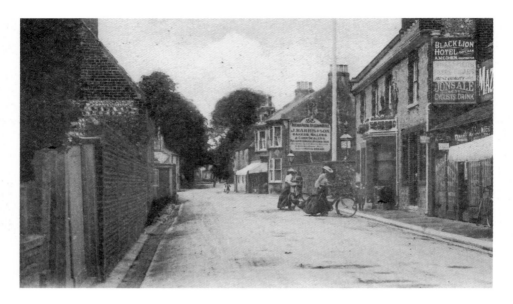

'Too Many Bicycles and Now Too Many Motor Cars'

Two ladies dismount from their bicycles outside of the original Black Lion Inn in Patcham's Old London Road around 1905. The small general store to the right of the inn was to become the Lion Motor Works within a few years. The Patcham Postal Telegraph Office was in Joseph Harris & Sons, bakers, millers and corn dealers, the double-fronted property behind the cyclists. Harris had started the business in the mid-1870s and was responsible for building the windmill on the hill at Waterhall in 1880. Notwithstanding the emptiness of the road, various accounts of Patcham in the early twentieth century refer to dust, no doubt occasioned by the heavy traffic along this highway. Until the general employment of tarmacadam on road surfaces after the 1920s, frequent visits by the water truck to dampen road surfaces was an urban necessity.

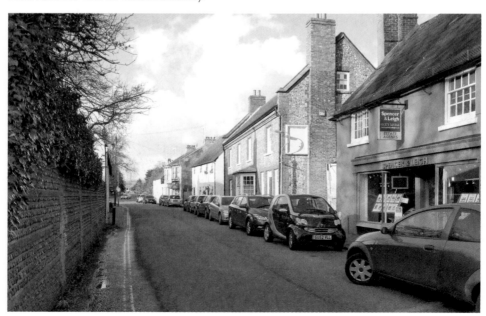

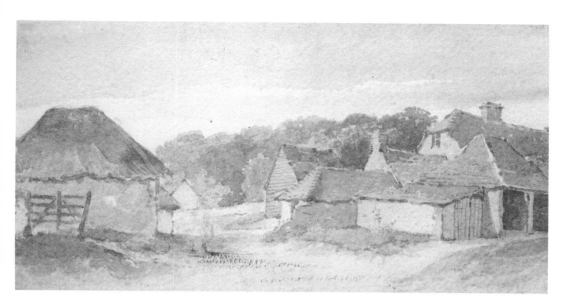

'Neither Pretty, Nor Ugly but Passable'

A watercolour recording by George Earp of Brighton of the farmyard of Court Farm, Patcham, around 1874. Many of the buildings pictured survived until the 1950s unaltered, but the farm with its 733 acres has been owned by Brighton since the 1920s. Those still in existence today have varied uses. Previously the Manor House, and the seat of the Manorial Court, the farm had been a possession of the Marquess of Abergavenny since 1439. It is notable for the number of substantial buildings that hint at its former prosperity. These include the longest barn in Sussex. The timber-clad building seen centrally was a well house that housed a donkey wheel until the twentieth century. Hidden behind it stands the seventeenth-century circular dovecote, still retaining its revolving potence. Down the sloping road in the mid-distance, and fronting the church, was the picturesque village pond that was sadly drained in 1937.

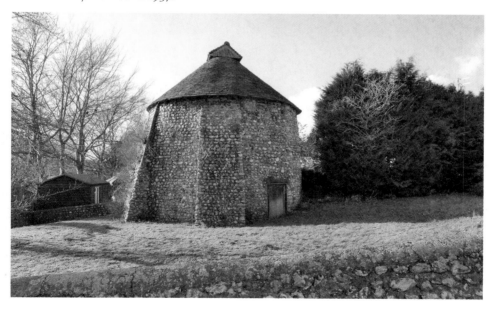

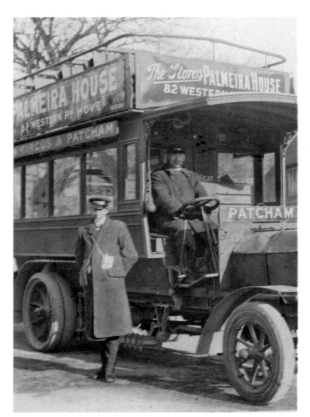

'The Patcham Express'

'The simplest way of reaching Patcham is by motor-bus from the Aquarium', assured the Ward Lock guide in 1926. Conductor George Scotow of 114 Springfield Road, Preston, stands beside his bus and driver near Patcham's Victoria Fountain that reflects itself in the side windows. A bus would later demolish the 1887 fountain believed to be the site of the Wellesbourne pool. The destination board on the side of the bus 'Preston Circus and Patcham' suggests that this is the earlier service that ran between those two points and, until the war, was horse-drawn. The vehicle itself has the appearance of having been converted from an earlier horse-bus. The lower photograph shows the same destination after 1929 when the new Black Lion replaced an earlier house. At the bottom of Church Hill a van waits outside of the novelty Japanese Tea Gardens, one of several that catered for intrepid visitors from Brighton.

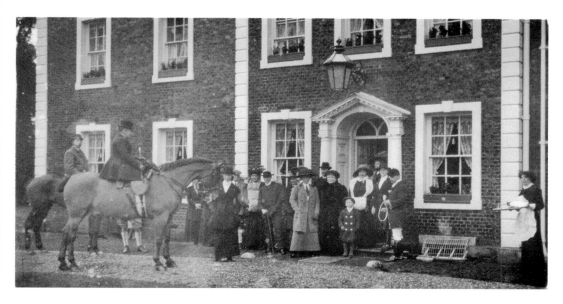

'The Hares on These Wild Hills Run Straight'; Patcham Place, 1910

The Brighton and Brookside Harriers meet at Patcham Place on 16 December 1910. A maid advances with the stirrup cups from the right. The Harriers were immortalised by Sir Richard Levinge's 1858 amusing 'A day with the Brookside Harriers at Brighton'. Although Levinge disapproved of hunting hares (comparing the event to hunting in Italy), he admired the beauty of the hounds and the master's green coat! Patcham Place was, in 1910, the home of the Misses Dobson, who no doubt stand at the elegant front door. The simple yet remarkably handsome house dates from John Paine's rebuilding of 1764. The painted quoins betray that its façade is covered with black mathematical tiles rather than glazed brick. Bought by the Corporation in 1926, the park became a recreation ground and the house, from 1939 until the expiry of the lease in 2007, a youth hostel. In early 2013 the house was sadly up for sale.

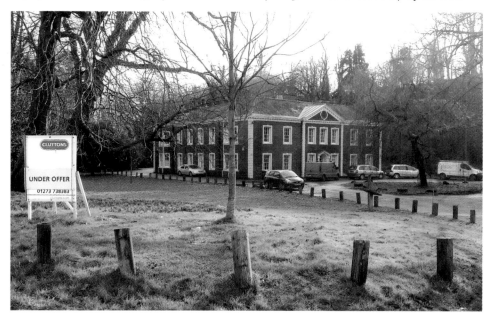

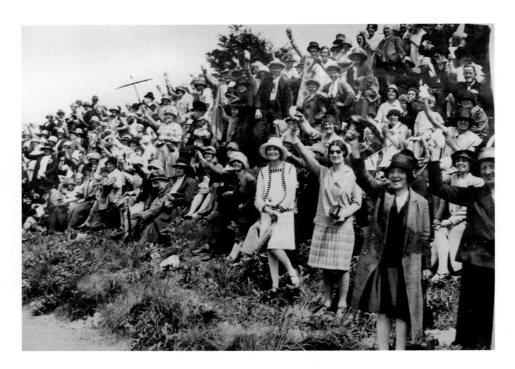

The Visit to the Boundaries

Waving hands, flags, streamers and parasols, loyal Patchamites crowd the railway embankment to cheer the Duke and Duchess of York on their way to lay the foundation stones for the Pylons, marking the new Brighton boundary, as part of the Town's Greater Brighton Celebrations on Wednesday 30 May 1928 around 11.50 a.m. The future king and queen had arrived at Brighton station at 11.24 a.m. and were driven straight to Patcham and beyond, along the London Road, and its straggle of new houses and bungalows, seen below from the embankment, and now either lost to road works or rebuilding. Following this they visited the Preston Park horse show before lunch and made a varied selection of visits including the unveiling of a commemorative seat at the newly acquired Devil's Dyke, and tea at Rottingdean.

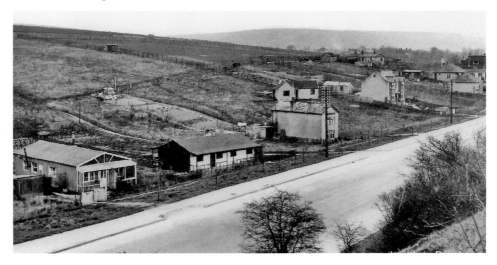

Walk Two

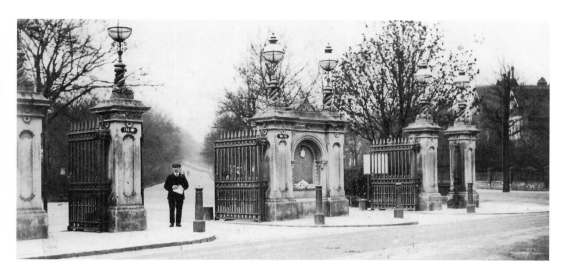

Preston Park Avenue; '1884, Houses Building or Empty'
The South Gates of Preston Park looking up the Ride about 1906. The last gate pier on the right survived the alterations of the late 1920s because the adjoining railings remained until 1936. Beyond it may be seen the start of Preston Park Avenue and its first house. Building commenced in Preston Park Avenue in 1883 and by 1885 Thomas Gates the builder was living onsite in number 1 while numbers 14 and 15 (The Manse and Uplands) were the only other houses finished and occupied. By 1889 number 1 was called Spencer House but by 1894 it was renamed Wayside and occupied by surgeon Bernard Roth JP of Brighton and Queen Anne Street, London. At first the façade was tile hung like its neighbours, The Chestnuts and The Manse, but at some time it was given a half-timbered façade to match the Park Lodge. Sadly, Wayside was replaced by Preston Mansions around 2005.

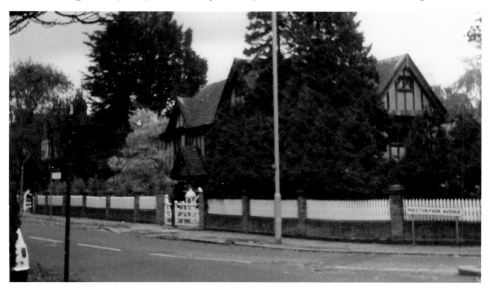

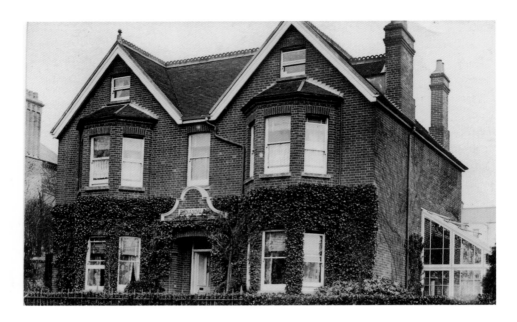

Caledonia in Preston

Annandale, 16 Preston Park Avenue, in the 1920s when owned by Major General Thomas Poole, TD, was one of several houses in the area named after the Scottish strath. Built in 1886, it was, like its neighbouring houses, comfortable, double-fronted, detached, and built of red brick. A Flemish gable topped the entrance porch and framed a moulded terracotta house name plaque. A side drive led to a stable at the end of the garden. It was a Victorian fashion for houses to be mantled in creepers to produce a soft aura of age, and Annandale was no exception. A handsome, well-maintained property, it was with dismay in 1971 that local residents found both Annandale and its neighbours, 15 and 17, boarded up and condemned to redevelopment. Flats now occupy their site. Alarmed by this threat, the author subsequently photographed all of the houses in the Avenue for posterity.

Adela Villa, Imposed Classicism

22 Preston Park Avenue was the first house in the road to fall prey to the property developer. Built in 1892, and originally called Caerbrock, it was soon renamed by its owner, the cigar and cigarette manufacturer Louis Coen (1863–1922), after his wife. A somewhat plain villa, with polygonal bays ornamented with terracotta tile panels and a rather strange wooden balustrade fronting the attic room. Its delight, however, was the remarkably grand Tuscan porch, which made it a favourite with the author from his childhood. This was the only classical architectural feature in the Avenue. The house also remarkably retained its original railings, possibly through these being smothered by a hedge during the wartime desecration of properties. This photograph was taken in July 1969; by the end of the year it was demolished and replaced by flats. A similar fate was to befall number 14, the Manse, the Revd Alexander Hamilton's tile-hung house of 1884.

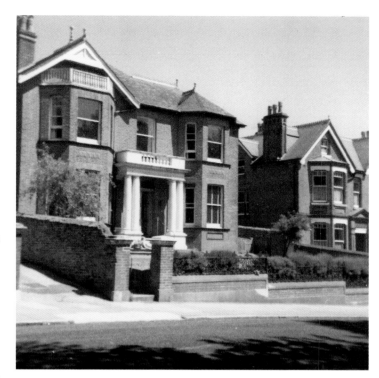

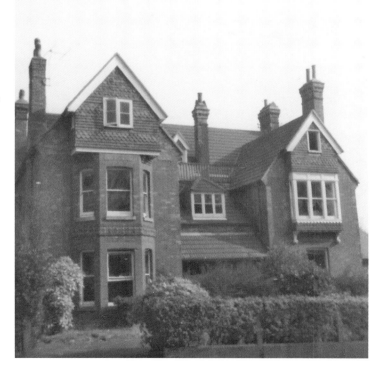

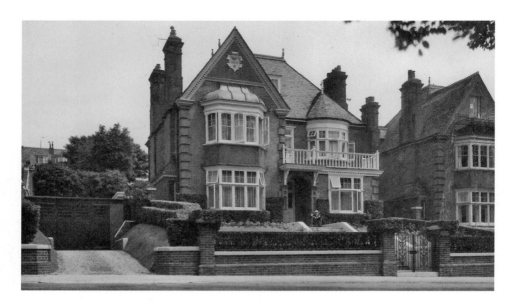

Victorian Tudoresque; 27 Preston Park Avenue

St Mildred's in the 1920s by Mora of 77 Preston Drove. The original gates and railings can be seen and the garden is offset by the fashionably whitened wall copings. The elderly owner, Charles Baxter Esq., sits at the front door. Originally the Avenue boasted a trio of these charming villas at 25–27, with their ogee Tudoresque lead-roofed bays and white-balustered balconies. Built in 1899, they bear many similarities with Withdean's Tower House. For many years 27 bordered an unused plot of land that was developed in 1935 into the rather exotic, and continentally *moderne* Park Court, that somehow suggested ski resorts to the 1950s child's mind. At some time a dwelling, perhaps for a chauffeur, was constructed above 27's garage. Alas, both 26 and 27 fell before the hand of the developer in the 1980s and are now usurped by a monolithic, hooded, and particularly regrettable block of flats called Whistler Court.

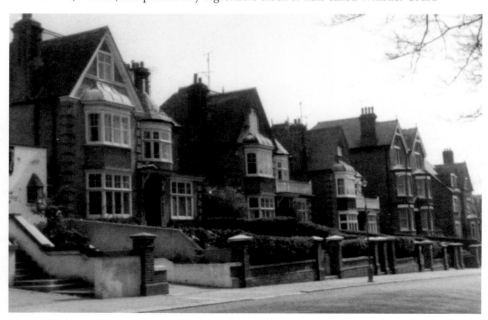

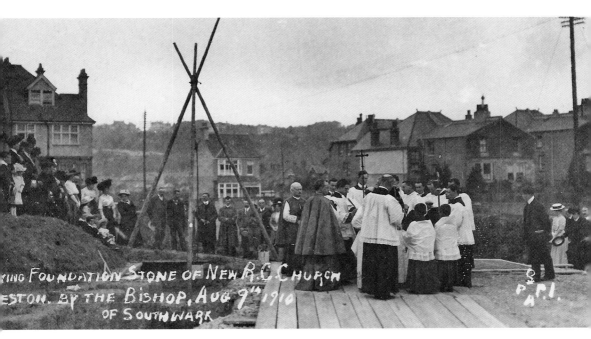

LAYING FOUNDATION STONE OF NEW R.C. CHURCH
...ESTON. BY THE BISHOP, AUG 9TH 1910
OF SOUTHWARK

'Preston Castle' ...
Built by the Romans!

On 9 August 1910 the Bishop of Southwark laid the foundation stone for Brighton's Roman Catholic church of St Mary's, Surrenden Road. The ceremony partially took place on the terraces of the adjacent cricket ground and on site. Houses in Harrington Villas appear behind the tripod winch in the photograph. Designed by Percy Lamb, it was built by Packham, Sons & Palmer of Preston in Kentish ragstone with Bath stone dressings. Father Hopper was determined that the tower should be the first landmark train travellers to Brighton saw, and finished that at the expense of the Founder's Chapel and Sacristy before money ran out (much to the annoyance of its benefactor). Mass was first celebrated here Easter Sunday, 1912. Unfortunately, Lamb's designs were not carried to fruition through lack of money and the north door never became the main entrance as planned. Additions in brick completed it in the late 1970s.

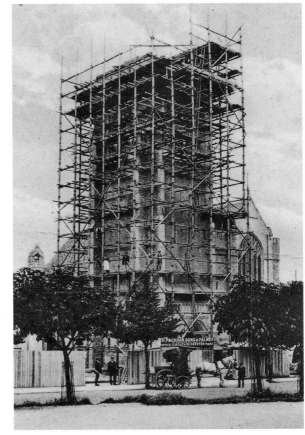

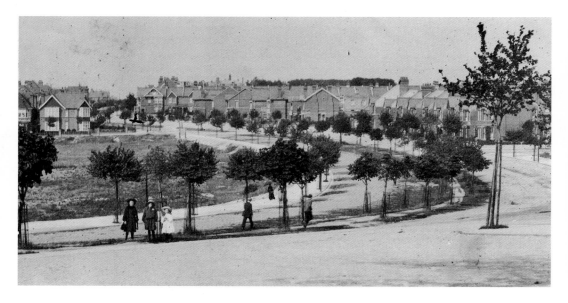

The Horse Chestnuts of Surrenden from Herbert Road, 1911

Surrenden Road was laid out in the 1890s, with the Patcham end seeing completion first. The area in the photograph leading from Preston Drove was cut from 1894 following an agreement between Brighton Corporation and the Trustees of the Curwen estate. It was planned on a grand scale and the central island was provided with a footpath flanked by pairs of horse chestnut trees. From local deeds it is clear that the new section was originally intended to be called Surrenden Crescent. Serendipitously, this postcard is marked with a cross indicating the Rosary featured on p. 59 of this volume. At that time its attic balconies commanded magnificent views to the south. The houses bordering Gordon, Bates and Loder Roads appear on the right and in the reversed view of 1910 seen below. Houses at the top, northern side, of Harrington Road appear to the left beyond the waste ground.

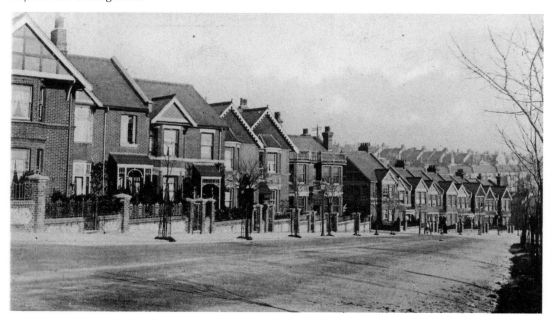

Slate Roofs and a Lost Garden

Two views over Surrenden Road from the veranda at 79 Preston Drove dated 1947 and 1960. Bordering Herbert Road are the gardens of the Park View that, during the war, had turned to allotments. In 1960 a row of garages seen to the right were built on the hotel's orchard. A row of garden chalets and finally houses facing Surrenden Road followed. In the hollow surrounded by hoardings is the Preston Park Baptist church. In the late 1960s the flats, Acacia Court, were built fronting Herbert Road. In the distance Whittingehame College sits on the horizon. Herbert, Gordon, Bates and Loder Road were designed for artisan housing. Much of Surrenden Road's land had belonged to Eliza, Lady Ogle of Withdean Court, who had sold it for development since the 1850s. On her death her heirs, the Curwen family, continued the process, naming the area now known as Surrenden after her mother's home, Surrenden Hall in Kent.

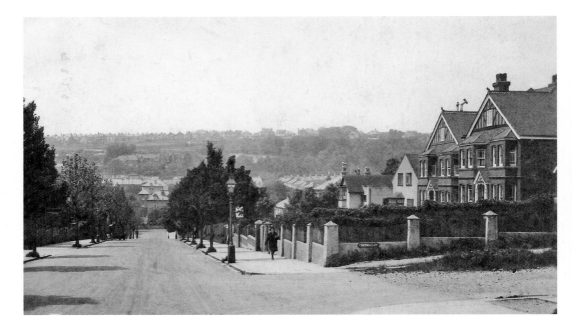

Harrington Road, 1928 and 1905

Harrington Road looking towards Preston Road and Clermont Terrace above. The line of poster hoardings on the upper approach to Preston Park station appears above these and houses now crest the hilltop in Maldon and Dyke Roads. On the right Cornwall Gardens displays an unmetalled road surface showing that it had not yet been adopted. Adjoining it the two substantial semi-detached villas are some of those built by W. B. Taylor in Harrington and Knoyle Roads. They sit on a plot of land once called Glebeside. This overlooked, and may have once have adjoined, the Glebe or land apportioned to the vicar of Preston, which stretched in a great L-shape down the hill and joined the vicarage garden on the London Road. It was sold at the end of the nineteenth century and Taylor's houses on the southern side of the road (shown below in 1905) erected on it. He lived at number 8, Harrington House.

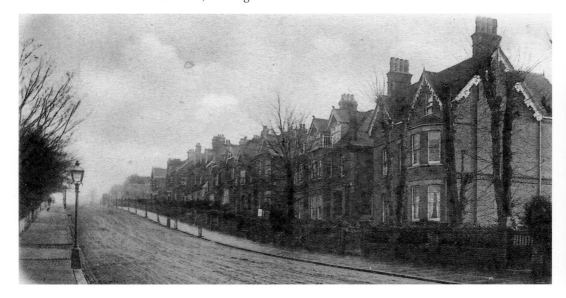

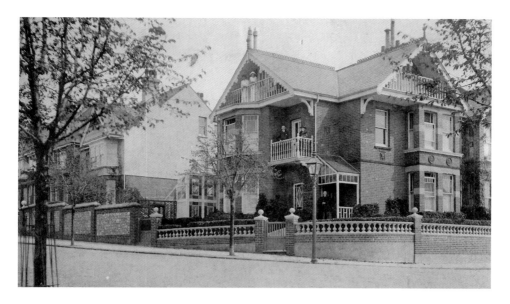

'Aunt Ting's House, Preston'

This attractive villa clasps the north-western corner of Loder Road and fronts Surrenden Road. In 1908 it was called The Rosary and was inhabited by the Revd Oscar Hubert Leake (RC), 1857–1932, and Miss Leake, the Aunt Ting of the photograph's inscription. They can be glimpsed at the front door and on the balcony. Staff look down from one of the attractive attic balconies, a feature of many of the late Victorian and Edwardian properties in Preston. The red-brick façade is embellished with classical terracotta plaques in the form of rosettes and garlanded *bucrania*. The white-painted woodwork and perimeter balustrade contrast beautifully with the façade's brickwork and the garden's evergreens. A grapevine occupies the attractive glasshouse with its stained glass windows. Leake assisted Father Hopper at St Mary's until 1914. The first house to the left (number 50) was demolished in 1960 to allow the building of a new close behind.

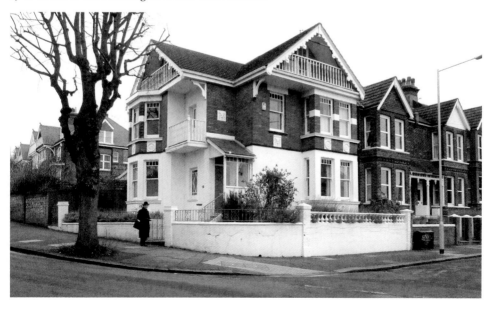

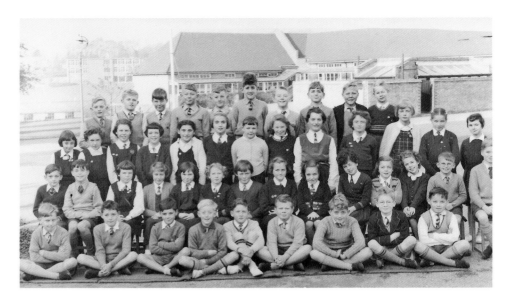

The Class of '58

In gymslips and grey pullovers and sporting the school colours of navy and gold, Mrs Moore's class pose at Balfour County Primary School in 1958. The children wear plimsolls having just been country dancing on the lawns. The author sits front row, third from right. The girls' lavatory block and the classrooms of the infants' section of the school appear behind. Beyond is the school canteen and, on the rise above, the recently opened Dorothy Stringer Secondary Modern. Whittingehame College lay beyond. Balfour replaced the small, corrugated-iron, 1910 Loder Road School in 1924. Set in acres of grassland and run by the benevolent headmaster Eric Slater, Balfour was a delightful school. It boasted classroom-width concertina windows for hot weather. Dorothy Stringer's first XI pose after winning the 1957–58 league. Paul Beeson sits second to left. The school opened in 1955 and was built on playing fields, once part of Varn Dean Farm.

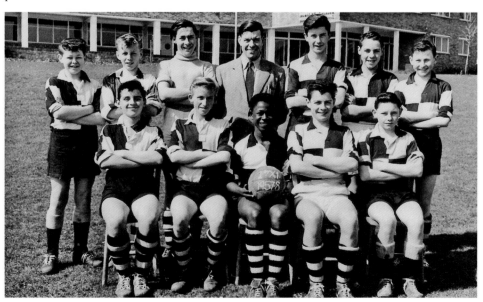

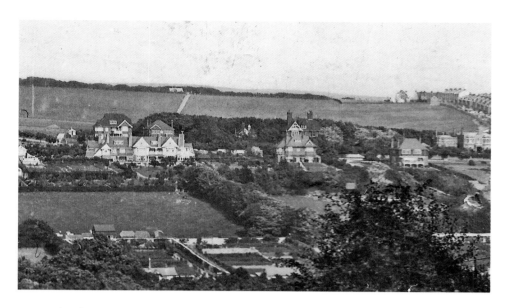

Surrenden from the Corkscrew, Withdean, 1911

A view across the Wellesbourne valley looking towards the heights of Hollingbury. In the left foreground may be seen the stables and kitchen gardens of Laine House and Effingham Lodge on the London Road. Above them stretches the splendid and gabled bulk of Fairlie Place on the west side of Surrenden Road masking the lower floors of the houses Maycroft and Ardshiel opposite it. Varn Dean Farm, behind them, is hidden by its extensive woodland, but the lane linking it to the Ditchling Road is clearly visible. The new Hollingbury Golf House appears on the horizon backed by the trees of the Hollingbury copse. The completed Osborne Road appears on the far right, and below it, the other mansions of Surrenden starting with Woodlands and to its left Mount Harry also on the east side of the road. Surrenden (right) and Varndean (now the Laurels and seen below) sit on the west side opposite them.

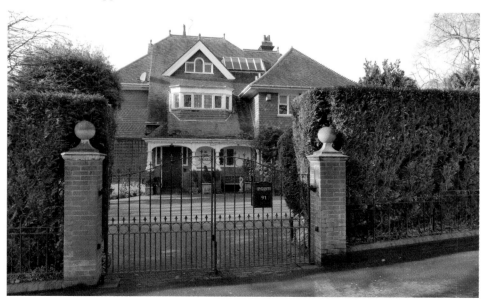

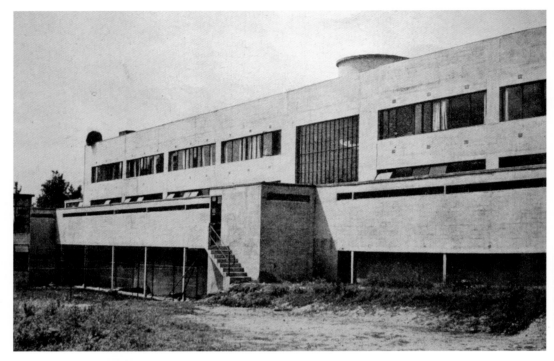

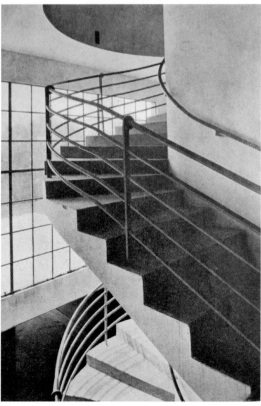

'The Jews' School', Surrenden Road, 1936
Whittingehame College was an important,
startlingly white and modern, ferro-concrete
addition to Preston's skyline in 1936.
Designed by Amnon Vivien Pilichowski
(later Vivien Pilley) it encapsulated Jacob
Halevy's unique creation, an international
Jewish boarding school aping Eton. White
walls set off rose-pink concrete floors, while
blue casements vied with the vermilion
handrails on the main spiral staircase
leading to the dormitories. Originally
designed to replace Woodlands and to
face east–west, the building was turned 90
degrees to face south when that mansion
was retained, thus disrupting Pilichowski's
architectural arrangements. Cost cutting,
bad construction and design flaws also
caused later problems. The classrooms
projecting from the south front boasted
under-floor heating (that soon failed)
and the building even possessed a water-
softening plant and electric refrigerators.
Requisitioned as a military hospital in 1940,
the school entered its golden age post-war,
but failed in 1960s. It was replaced by
Whittingehame Gardens in 1965.

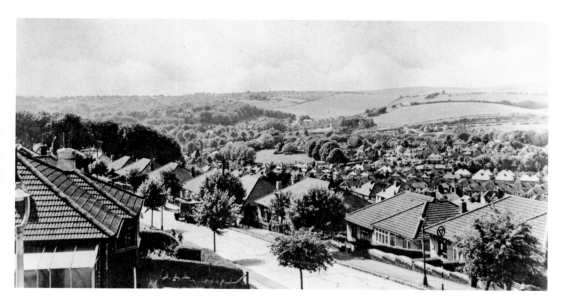

The View from the Post Office

Brighton's 1928 expansion and Patcham's subsequent absorption occasioned a surge of new development around the village. New estates and building developments rapidly spread over the surrounding hillsides, branching out from Ladies Mile, Carden and Braybon Avenues, and Valley Drive. 'The Lady's Mile' was originally a drove between Patcham and Stanmer. Originally called 'The Drove(way)', its later fame and name change arose from it being the start of a superb turf gallop all the way to Clayton Mills and even to Lewes. It was one of Patcham's earliest roads to be developed, and much of it by George Ferguson from the late 1920s. Woodbourne Avenue, high on the slopes approaching Surrenden and Hollingbury, was another late 1930s development. The photograph, taken from the post office at the corner of Beechwood Avenue shows it around 1950. The view looks west across Patcham toward the fields and windmill at Waterhall and the woods of Westdean.

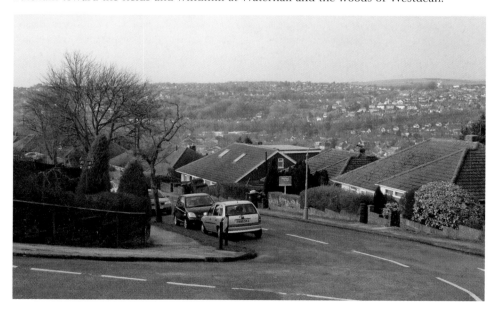

Walk Three

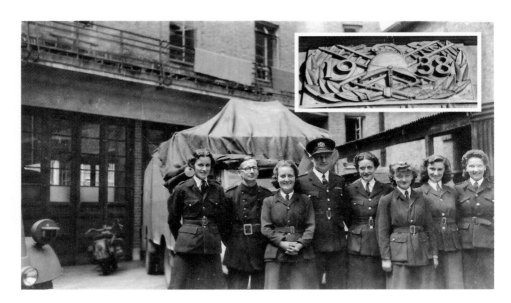

Brighton's Noble Fire Brigade

A picture of Preston Circus fire station around 1950, if not earlier, showing my aunt, Leading Firewoman Joan Mavis Beeson (later Claydon, 1917–92), third from left, with her colleagues in the courtyard. Next to her in officer's uniform is Henry Alfred Stanislas, who was awarded the Queen's Fire Service Medal for distinguished service in January 1956 and was Divisional Officer (Deputy Chief Officer). Joan had started her career in the AFS when a station was established in Preston Drove Motors during the war. Graeme Highet's new brick and Portland stone fire headquarters building at Preston Circus had only been opened in May 1938. It replaced the 1901 structure that itself had succeeded the partially demolished Longhurst's brewery. One of the surviving brewery walls, complete with cross braces, and now part of the Duke of York's cinema, appears at the rear of both photographs.

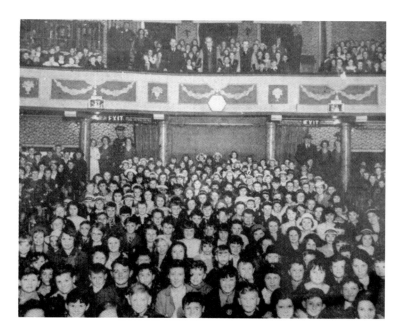

Full House! A 'Capital Programme' at 'The Duke's'

On 7 May 1935, Brighton's children enjoyed a morning at thirteen participating cinemas and theatres celebrating the King's Jubilee. Seven hundred pupils from Balfour Road, Preston Road Church of England, St Joseph's and St Martin's schools were treated at the Duke of York's cinema, Preston Circus. Celebrations started at 9.30 a.m. when Alderman Richard Major read a mayoral address. The King was then 'heartily cheered' and the National Anthem sung, while pictures of George with the Navy were shown on the screen. The programme included Walt Disney's coloured cartoon 'Silly Symphony', Laurel and Hardy's 'Fra Diavolo' and 'Long live the King', 'a spectacular review' of the reign. This rare auditorium view shows that by 1935 the two boxes on either side of the balcony had been dismantled to accommodate more seating. The cinema (seen below in 1922) opened in 1910 and was adapted from the malthouse of Longhurst's brewery that was demolished in 1901.

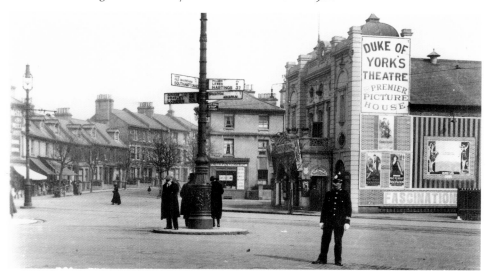

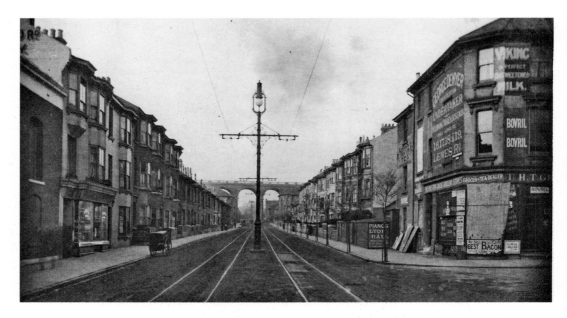

Beaconsfield Road, 'Now Covered with Bricks and Mortar'

Beaconsfield Road is first mentioned in the town directories in 1876 with the cryptic entry 'Houses building'. This followed the passing of the Stanford Estate Act in 1871 to allow Ellen Stanford of Preston Manor to raise money on her Brighton property to offset her husband, Vere Fane Benett's, debts. As a result the previously empty fields south of the viaduct were completely covered by new housing between 1871 and 1880. The inhabitants of the little terrace and cottages in Viaduct Road would no longer enjoy a country view. Beaconsfield Road was wide and lined with middle class properties, some of three storeys in height. It led through the viaduct to the more substantial houses of Beaconsfield Villas. Sadly the trees visible in the 1910 photograph no longer exist.

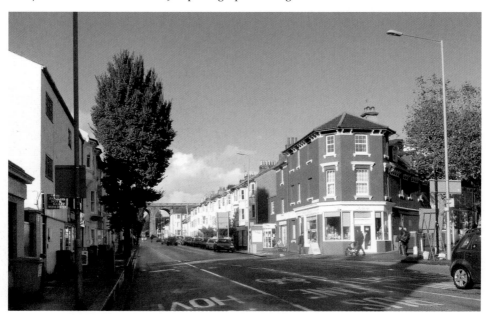

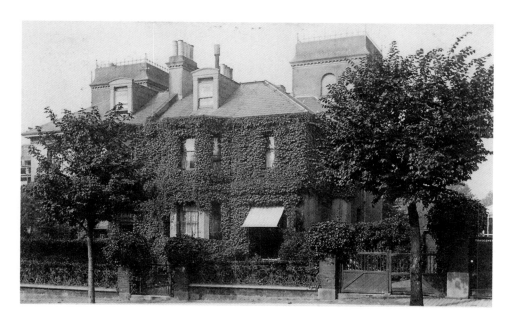

'Merry Christmas and Good Digestion'

This was Rosedale, 7 Stanford Avenue, and the residence in 1905 of F. J. Snape Esq. who, on 21 December, sent its likeness and Yuletide Felicitations to Miss Whitwell of the Pit Bar at the Theatre Royal. Like its attached neighbour, Molcombe, this Italianate villa, with its galleried tower is smothered in ivy and Virginia creeper following the romantically rustic fashion of late Victorian Britain. Even the gateposts have their own clipped mounds and evergreen hedges back the long lost railings. The ubiquitous sunblind protects the graining of the front door. These were some of the earliest villas in Stanford Avenue dating from around 1879–80 when the grand road was laid out to link the Preston Road to the Ditchling Road. Their rendered façades contrast with the later brick villas further up the hill. A matching new wing was added to the east of the house at a later date.

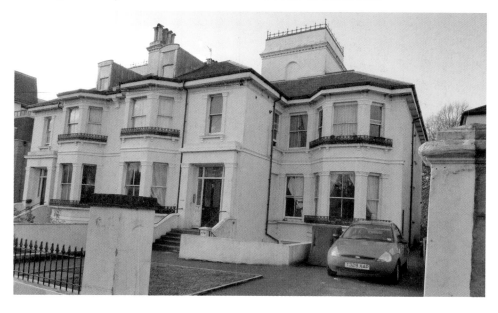

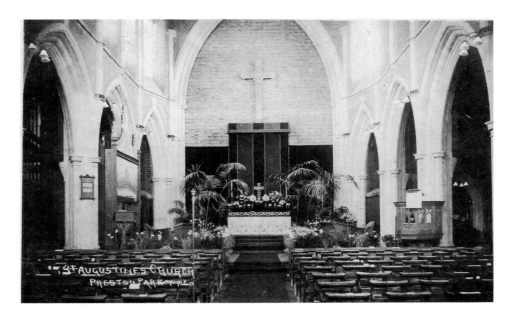

Awaiting a Chancel, St Augustine's, 1906

The nave of Granville E. Streatfield's 1896 St Augustine's church, Stanford Avenue as it was around 1906: a handsome building in the Perpendicular style and employing red brick and stone dressings. The brick is laid in Flemish bond pattern. Like St John's at Preston, its nave first lacked a chancel through lack of finance. Eventually a large apsidal chancel with an ambulatory was built in 1913/14 for which Sir Thomas G. Jackson acted as consultant. The western end of the church was never completed however. The adjacent and attractive church hall and Sunday school was a memorial to Queen Victoria in 1901. Internally it featured a gallery on three sides. Its façade is particularly delightful if now sadly decayed, with a door topped by a broken pediment. Now redundant and a victim of lead thieves, the buildings await redevelopment. Below, attendees at the 1921 Summer Fete pose at the vicarage.

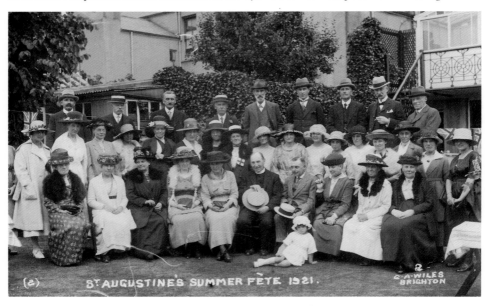

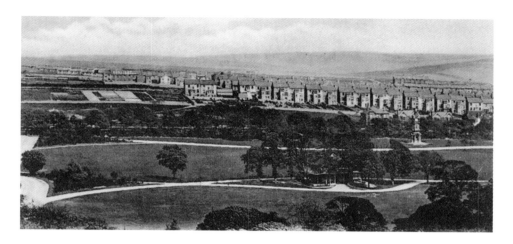

Beaconsfield Villas

Beaconsfield Villas and the growing area south of Preston Drove around 1894. Named after Benjamin Disraeli, Lord Beaconsfield, and developed from the 1880s, Beaconsfield Villas continued the line of Beaconsfield Road up the steep escarpment to the north. From Lucerne Road northwards its route joined the line of a historic approach to Cowley's Farm from the Drove. This had turned east approximately where Lucerne Road now runs, to access the farm buildings on the site of Blaker's Park. Beaconsfield's earliest villas were double-fronted with rendered, unpainted façades. Some fortunately still retain their railings and balconettes. By 1903, 108 properties were inhabited and, by 1911, this had risen to 138 and reached Preston Drove. In the days when Britons rhymed 'Nestlé's' with 'wrestles', Beaconsfield was always locally pronounced 'Bee-cons-field' and not 'Beck-ons-field' as other parts of the country would have it. Likewise few locals dreamed of 'Mont-peel-ee-ur' as being pronounced in any other manner.

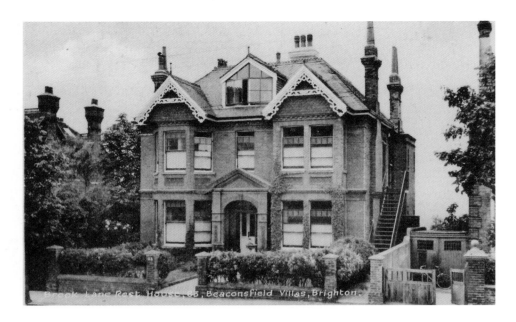

Somewhere to Convalesce

Benevento, 83 Beaconsfield Villas, around 1955. In the previous decade the house became a convalescent home called the Brook Lane Rest House and it was to remain so until the mid-1960s. This brick-built, tile-hung and detached house was built in the late 1890s when rendered façades were no longer fashionable. In 1903 it appears in the directory only under Benevento and was not numbered. Its occupant was Mrs W. Lawson. The villas of the western side of the road were terraced into the steep hillside and the rear view shows the extra storey thus gained. Benevento's gates and railings were lost to the ridiculous wartime scrap metal mania that was fostered by the government. Britain's streets were devastated in this exercise in solidarity building. None of the architectural ironwork collected was suitable for the war effort and most was eventually dumped at sea.

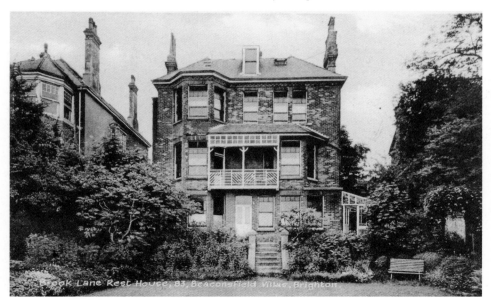

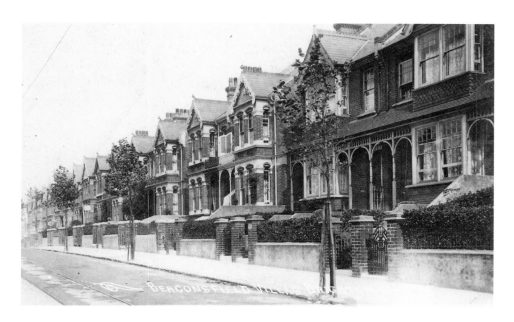

'Fine House ... All the Girls are Very Jolly'

Mary G. sent this card of houses on the opposite side of the road to her Training College Hostel at number 101 Beaconsfield Villas in 1911. It shows number 104 and its neighbours. At that time 104 was called Elmhurst and was the residence of Mrs M. H. Crafer. Directories show that these houses on the east side of the road, and approaching Preston Drove, were still under construction or unoccupied in 1903. Those seen in this photograph have the same pattern of gates and railings as still survive in the Drove at numbers 75–89 and originally there decorated numbers 53 upwards. The road here is lined with semi-detached villas that, in their variants, reflect the remarkable changes that were underway in house design at this period. Numbers 100–106 are unlike their companions and employ woodwork instead of cast iron on their façades.

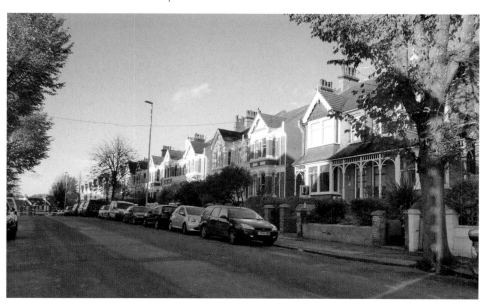

Walk Four

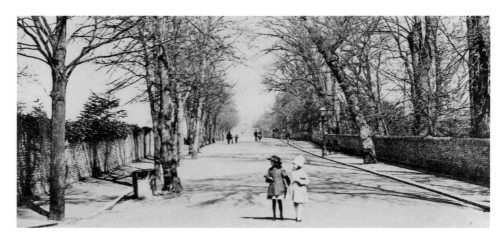

The Hazards of Traffic

Sunday morning at the bottom of Preston Drove in 1911. Two wary young pedestrians stand in the middle of the road and clasp prayer books and each other, searching for oncoming traffic along the Preston Road. Originally part of the ancient drove-way between Portslade and Lewes, by 1902 it had become Preston Drove. Planned on a magnificent scale, it yet retained a level of rusticity especially near this junction, where mature trees were allowed to remain beyond the gutter. The high walls of the vicarage, on the left, had been set back on the west and south sides in the 1890s. Those of the manor close the scene on the right. By the 1960s this crossing had become extremely hazardous and many accidents and fatalities occurred. Traffic lights and double yellow lines helped, but their positioning as seen in the background of the 1986 photograph, ultimately ruined erstwhile profitable village shops, by prohibiting passing trade.

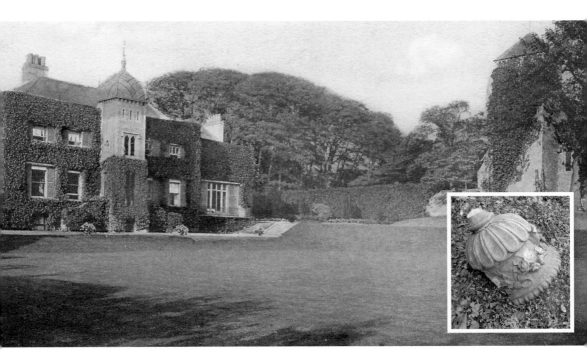

A Flanders' Mare?
Preston Manor, 1900

Preston Place (Manor) underwent many alterations in the nineteenth and early twentieth centuries. Service wings and outbuildings were added and then replaced, and the southern façade was given a Tudoresque touch around 1880 by the addition of a stone entrance tower containing a smoking room and a lavatory above the porch. It was embellished with lancet windows, a carved Tudor Rose and a Tudor-style dome. This was all in deference to the widely held but mistaken belief that Anne of Cleves had lived in the house. In 1905 the Stanfords had the tower demolished as part of Charles Peach's alterations to the house. Only the porch survives in an altered state and the Tudor Rose blossoms in the front lawn. The manor followed the Victorian fashion of creeper-clad façades. A gem of a house and formerly always beautifully maintained with pride by Brighton, today, alas, much appears sadly neglected.

73

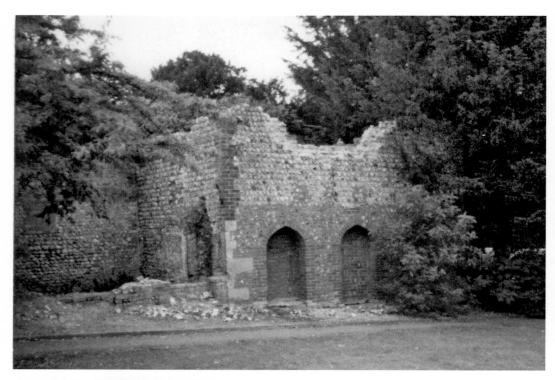

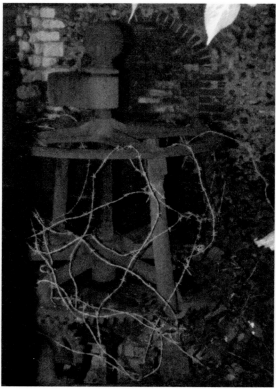

The Forgotten Well and the Lost Dovecote

East of the manor, and forming part of St Peter's churchyard wall, stands a ruined listed building that was once both a well-house and a dovecote. An 1818 watercolour suggests that only the western part then existed or was recorded by the artist. This was a roofed building with open arcades and, once weather-boarded, flint walls. It housed an iron horse gear that still survives within, above a 130-foot-deep well. Water was pumped into a large tank for the manor and village. A dovecote above a storeroom was later attached to the east side. By 1900 the well-house was unroofed and its window and arcades bricked up. Brick crenellations similar to those on the manor's garden arch had been added. Neglect and invasive plant growth occasioned the dovecote's collapse in 1986. The photographs show it in 1986 and tidied in 1987. It is now in a shamefully perilous state.

Flowery Banks, the Hedgerows of Preston Drove

The lower portion of Preston Drove and newly planted trees at the kerbside with the Drove's original hedgerow surviving behind. In the 1860s the hedgerows of the Hove and Preston's Droves were noted as excellent places to observe native flora such as wild heartsease and sweet violet. Brighton's generally treeless agricultural landscape was often referred to as a 'barren waste'. Before domesticity supplanted the bordering hedges of Preston Drove, they sheltered brambles, dog-wood, wild rose, willow palm, black horehound, travellers joy, alder, ash, ivy and dove's-foot geranium. The hedges in this photograph bordered the *insula* shared with Knoyle and Bavant Roads that contained allotments. The horizontal line of the vicarage's east garden wall may be seen between the trees. In the 1930s modern houses were erected on this site, probably by Henry B. Nixon of Belleview, Knoyle Road. The Victorians' grand planning of the Drove may be appreciated in the 2013 photograph.

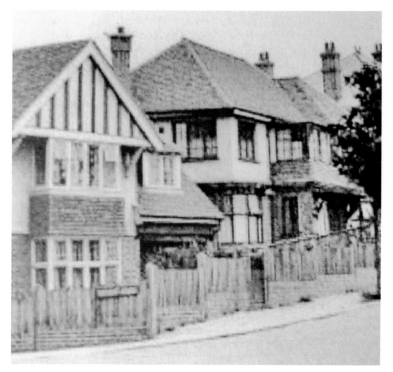

'The American House', 1935 and 1987

35 Preston Drove was the first of the late 1920s houses that continued the line of building down to Preston village. It was an unusual building that daringly incorporated a bow window across one corner and a glazed loggia above a tile-hung porch that originally continued outwards and rested on heavy curving wooden brackets. The entrance hall, and the loggia above, was once beautifully painted with Chinese murals, while the front garden was also oriental in inspiration and enclosed by wooden fencing and gates. My mother always referred to it as 'The American House' because of its first occupants, James and Sarah Harwood. James was English but went to America as a hotelier. They were first cousins and she was disinherited for marrying him. Leaving America after 1896 they lived in Hove until moving to Preston. James died in January 1946 and Sarah five months later. The house retained its oriental features until the mid-1960s.

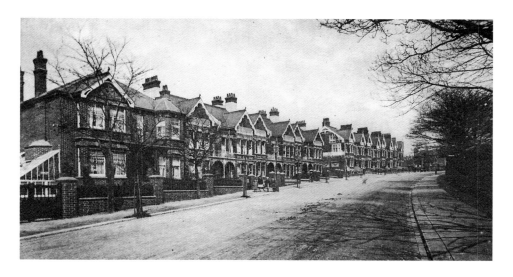

Rumours of Elephants, Preston Drove, 1909

Elephanta Lodge, of 1908, on the left, was for twenty years the first property reached in the Drove from Preston village. Named after Elephanta near Bombay, which was popular with the colonial British on account of its rock hewn temples, Elephanta was for some years the residence of Mrs Lockhart, possibly an ex-colonial. The story that she was connected with the circus and visiting elephants seems rather unlikely! Elephanta's conservatory contained an impressive grapevine. By the 1920s, renamed Waytefield Lodge and numbered 37, it was owned by Edgar Jones, whose chemist's shop stood at the corner of Beaconsfield Villas. The adjoining houses just predated Elephanta. On the corner of Harrington Villas appears the impressive western façade of number 53, Newbury House, William Browne's 1902 residence, with its dedicatory plaque to a member of the Harrington family and its long vanished wooden balcony. Its construction finally completed the adjoining early terrace of houses.

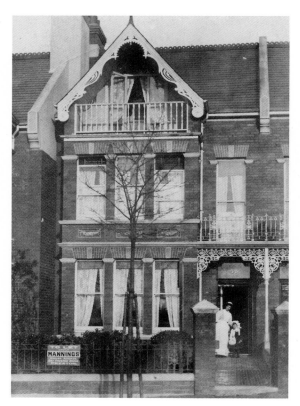

To Let, 43 Preston Drove

A maidservant and a warmly dressed little girl stand on the tessellated path before the door of 43 Preston Drove on a sunny winter's morning about 1910. Madame Terrell had been the first occupant but by 1911 an S. Collis was in residence. Brighton directories show that most of these houses had short-term tenants at this period and letting rather than purchasing was for most residents the accepted practise. The house and its adjoining villas were built around 1907. The veranda in the gable with its pretty pierced bargeboards fronts a bedroom, whose dressing table appears at the open door. The bedroom below it is also being aired. One of the newly planted trees lining the Drove appears supported outside. Apart from the loss of its front railings, the exterior of number 43 remains much as it was when first built.

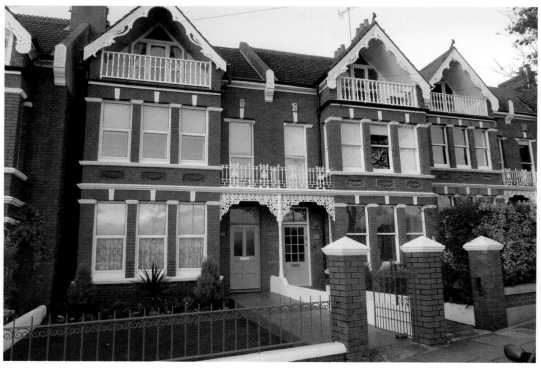

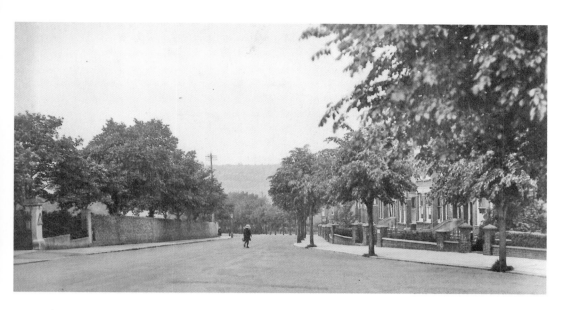

The Gate to the Downs

A traffic-free Preston Drove around 1927 as seen from The Park View Hotel. Surrenden Road curves off to the right and the North Gate of the park with its original railings and gates appears on the left. Unlike the southern and western gates the piers here never supported dolphin lamps. The adjacent wall letterbox enjoyed twelve daily collections as early as 1889. Until the late 1890s this area was open countryside and equestrians using the Ride could continue on to the Downs through this gate. The 1898 map of Preston and house deeds, illustrate that the second to fourth houses up from the corner of Harrington Villas were the first built in the otherwise empty Drove and just predate those adjoining the Park View that share the same design of railings. The lower Drove was always tree-lined and the original trees appear taller in the distance.

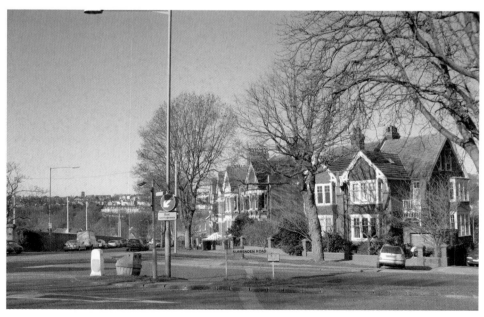

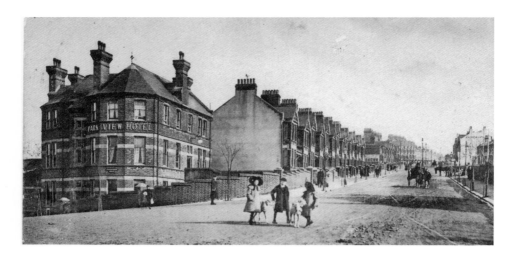

The Club on the Corner, 1907 and 1976

The Park View Hotel on the corner of Preston Drove and Surrenden Road was built by 1900 and was at first referred to as 'Preston Park Club'. It was intended to cater for wealthy residents and visitors attending events held in the park, and it had its own large garden behind it. An elaborate building of brick and Bath stone, it is now sadly damaged internally by unsympathetic alterations undertaken since the 1960s. The Public Bar, in the low and secondary Surrenden Road wing, was built only after much opposition from local householders. Originally it boasted elaborately engraved window glass. Stained glass and bosses carved with dolphins still survive on the floors above the hotel's side entrance. The main reception rooms faced Preston Drove. The Edwardian view shows the Park View and Preston Drove before the buildings of the two ranks of local shops near Beaconsfield Villas.

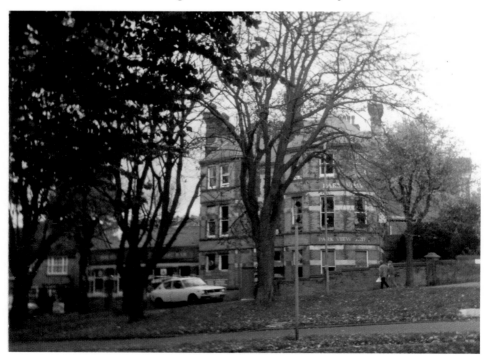

A Preston Family, Eden House, 79 Preston Drove in 1954 and 1962

Four three-storey houses adjoining the Park View Hotel were built by W. H. Crossley in 1898/99 on land from the Harrington estate. The rest of the terrace followed soon afterwards. The Drove here topped a steep escarpment that became front gardens and sloped down to the dining rooms. Drawing rooms were above on the ground floor. The slope saved the house railings from salvage in the 1939 war but not the gates. The attractive but soft brick weathered badly, eventually necessitating rendering. Named *South View* by Crossley, in March 1902, Thomas Thompson, a forty-four-year-old retired gentleman tea planter and his wife Augusta, bought 79 for £680 and changed its name. They lived there until he died in 1929. Mary Crawley was their live-in servant. Herbert Jex Beeson retired and died there in 1933. The 1962 photograph was taken in its rose garden and shows my parents, my brother Hugh, and myself.

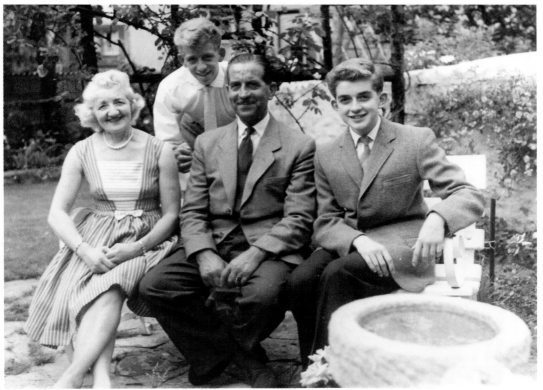

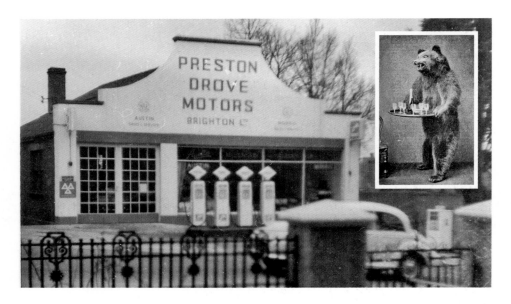

Preston Drove Motors; Carnations and Motor Cars

This site in Preston Drove sloped sharply to the south, and was occupied by a succession of nurseries specialising in carnations. It was free of buildings until 1929 when Albert Lambourne built lock-up garages on the lower level backing the gardens of Preston Park Avenue. A garage and showroom were later built, level with Preston Drove and, from 1936, was run by the motor engineer Neville Hodson, MIMT. A side ramp gave access down to the earlier garages. Requisitioned by the Fire Service for the war, it was not until 1946 that it reopened for business. For local children it was singular for the objects that ornamented its internal walls. These included aircraft propellers and various animal heads. Most memorable was the stuffed 'butler bear' that dominated the right-hand side of the front window holding a tray on which was generally advertised some garage product. The business closed in 2002.

'Well Supplied with Local Shops'

Preston Drove seen from the corner of Beaconsfield Villas around 1926. Local shop provision was deemed essential for the burgeoning estates of Preston. Including Preston village and the Fiveways, Preston Drove had three areas of shopping to cater for the needs of its neighbourhood. The central section ran between Havelock Road and the shops here illustrated just below Balfour Road and Beaconsfield Villas. All essentials were catered for from the ironmonger, coal merchant, greengrocer, butcher, baker, chemist, optician, creamery, confectioner, tobacconist, fishmonger, newsagent, grocer and even a sports outfitter. People were extremely parochial and as late as the early 1960s it was not usual for local shoppers to venture further than the nearest rank to shop. The 1935 photograph shows numbers 81–87, Preston Drove that stand just below the shops. It records for posterity the design of the front gates that were lost to war salvage.

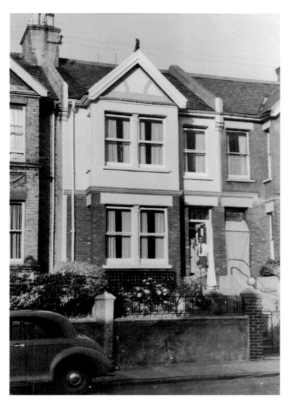

Evening Sunshine in Havelock Road, 1953 and 2013

The author and his parents bid farewell at 162 Havelock Road. They purchased the property in 1950 in order to be close to my ailing grandmother. They restored lost railings and gates and installed the then fashionable floral 'leaded lights' in fanlights and doors. Sunblinds shielded paintwork and afforded privacy, allowing doors to be left open during summer. Havelock Road was developed up to 1903, when The Crest, the handsome corner house on Preston Drove, was built. Many local shops served the road, both at the intersection with Lucerne Road, and at the turning to Preston Drove, where Dudeney's the grocer's held sway. In the lower rank was Mr Scott's Basinghall Electric Company, the source, in the early 1950s, of most television sets in the area. Cornelia James Limited's small, intriguing glove factory (now Glovers Yard), stood at 121–123 near the corner of Lucerne road. In 1954 we moved to Preston Drove.

The Coming of the Trams

The crew of a hand-cranked horse-drawn crane erect an overhead power standard for the new tram service in the centre of Preston Drove near its confluence with Waldegrave Road on this glass slide. The first tramcar ran on Brighton's electric tramway system to Preston Barracks on 25 November 1901. The line reached both Beaconsfield Road and Ditchling Road by 1902 and the connecting link, via Beaconsfield Villas and Preston Drove, was finished by July 1904. Sunblinds at doorways suggest that this photograph dates from the summer of 1903 and there is no evidence of rails in the roadway at this stage. The steady march of new houses up the Drove was then well underway as may be seen by the unfinished roofs and scaffolding at the right. The lower photograph shows the same section at the bottom of Lowther Road in the 1930s. Recent taste has seen the brick façades painted white.

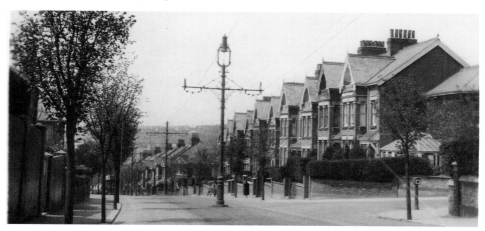

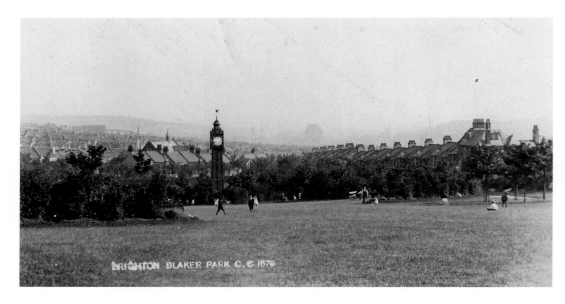

'Containing 4 Acres, 1 Rod and 1½ Poles'

Blaker's Recreation Ground, seen here in 1906 and 1928, was the gift of Alderman J. G. Blaker to Brighton and opened in 1894. Bounded by Preston Drove, Cleveland and Southdown Roads and Stanford Avenue and, with its smart railings, paths and shrubberies, it resembled a super-sized London square garden. The view from the park over Brighton to the south is still very fine. Blaker lived at The Romans, 79 Stanford Avenue so, although generous, the gift also ensured his property was enhanced by the proximity of a park. In 1896 he further gave the park's fine cast-iron clock tower that bears his monogram. By the 1950s one recalls the park as being somewhere to avoid because of dog fouling and it seemed sadly irrelevant to this child considering the proximity of Preston Park. Following the 1987 hurricane, reconstruction gave birth to the Friends of Blaker's Park who now protect its interests.

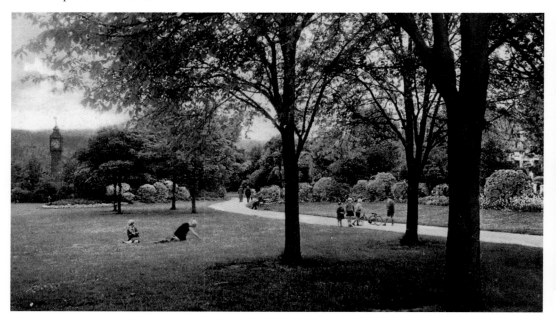

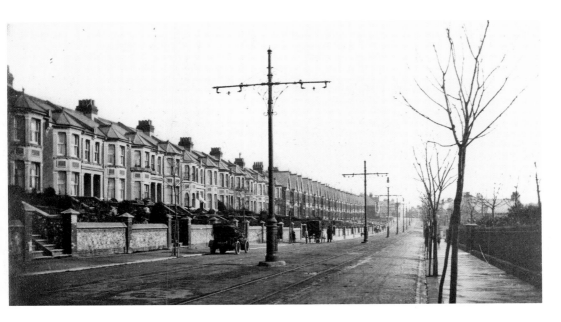

To the Five Ways

Looking east along Preston Drove one damp winter's morning, around 1920, towards Fiveways, with its shops and the crossing of the Ditchling Road. On the right the railings and north gate of Blaker's Park and an enfilade of young trees that joined those planted at greater distances on the north side of the Drove. The power standards and lines for the trams were then almost into their second decade. The trams survived until 1939 when replaced, on 1 June, by the 46A and 26A trolley-bus serving Beaconsfield Villas, Preston Drove and Ditchling Road. The houses on the left although aping earlier wholly rendered façades are an interesting transition in their display of brick. Only their bays employ rendering. Often ivy-clad and never generally painted until recent decades, rendered properties contrasted badly with the fashionably bright façades of red brick and white paintwork. In 2013 only 151 survives here in its interesting original state.

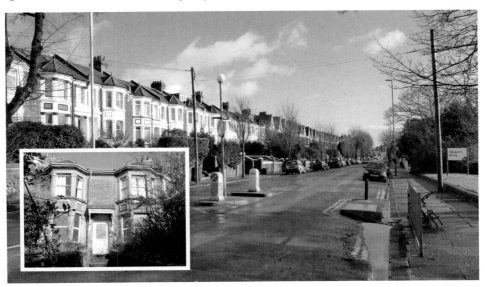

Walk Five

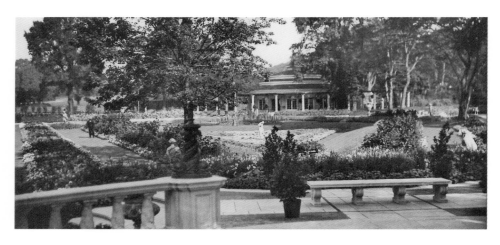

The Sunken Garden

From 1928 a remodelling of Preston Park was undertaken to include Bertie MacLaren's kite-shaped sunken rose garden. The park's original entrance gates were removed and, by the early 1930s, dolphin balustrades featuring the Victorian dolphin lamps, with their globes modernised into flambeaux lights, rose at the southern and north-western entrances. Legend gives the Rotunda café its origins at the British Empire Exhibition of 1924/25, although it does not appear in aerial shots of that event. The Tuscan columns cost £12 10s 0d each from the Empire Stone Company. Possibly the 1927 Winter Garden at Weston-super-Mare may have inspired Preston's Rotunda, pergola and lily pond. Always a showpiece for Brighton (the yew hedge was only trimmed with hand-shears), in recent years, like much of the park, vandalism and the reduction of park gardeners from seventeen to five has been problematic. Volunteer groups now assist in its maintenance.

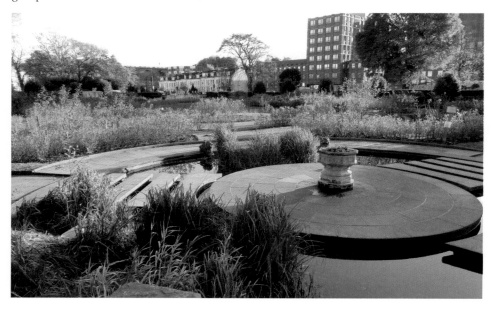

Sculptural Grandeur …
Missing Presumed Stolen

From the start, the rose garden was ornamented with sculpture, salvaged from elsewhere in the town. Thus the 1928 demolition of the aquarium entrance provided not only the splendid Barbezat bronzed, cast-iron copies of Mathurin Moreau's Four Seasons that had previously ornamented its clock tower, but also a variety of urns from its Pompeian staircase. Gargoyles also from the clock tower formed the lily pond's dolphin fountains, while the spectacular bronze lion's head waterspout originated from Brill's bath, demolished for the Savoy cinema in 1929. Vandalism, theft and decay have accounted for all but Summer and Autumn of the Seasons in the gradually disappearing array. Enquiry has disclosed that, tragically, the bronze fountain sculptures vanished in the late 2000s during an occupation of Preston Park Avenue by travellers and are replaced in fibreglass. The lower photograph features a pair of stone *putti* that for a while ornamented the pond in the early 1930s.

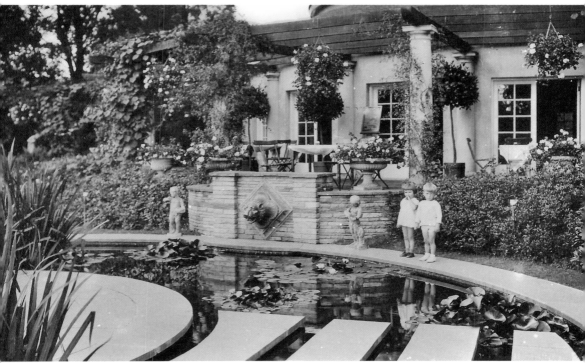

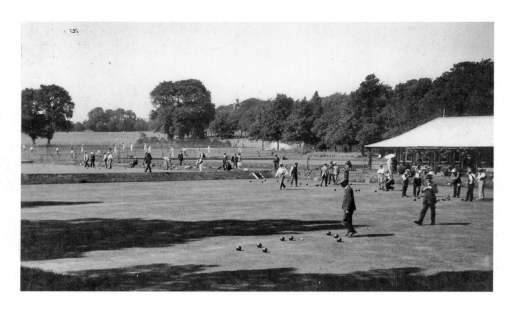

Bowled Over

The bowling greens and tennis courts as seen on 10 August 1925. Originally, only the green on left existed but the increasing popularity of the sport saw additional greens and a pavilion built. The new Floral Walk that intersected the courts and predated the rose garden also appears. The top photograph is taken from the carriage drive that cut across this area to the right of the bowling pavilion and ran close to the Lovers' Walk, passing the clock tower to join The Ride by the Cricket Ground. After 1928 its course was altered and additional bowling greens and the classical pavilion were laid across its southern route in 1935. The 1960s saw the prestigious Open Bowls Tournament run from the park. In recent years an apparent decline in the popularity of bowling, and the closing of one local club has seen greens given over to more boisterous sports.

SNOW SCENES IN PRESTON PARK BRIGHTON · 1915 (2) G·A WILES BRIGHTON

Outnumbered! Snow in Preston Park

Armed with two snowballs, a lady prepares to do battle with her young charges while a policeman keeps an eye on proceedings in this delightful 1915 photograph by G. A. Wiles. The engagement takes place on the southern side of the triangular shrubbery adjacent to the park's Drive and Central Gate on the Preston Road. The boundary railings appear behind the lady. The lower photograph, taken on 24 April 1908, shows The Drive with the dolphin lamps of the gate in the centre distance, and the triangular shrubbery on the far left. The upper façade of 169 Preston Road, a house that miraculously survived the 1960–70s destruction of its neighbours, appears to the far right. Even under snow the superbly manicured state of the park's shrubberies is obvious. This was the coldest April day experienced in Britain for thirty-six years and even then previous temperatures recorded were at the beginning of the month.

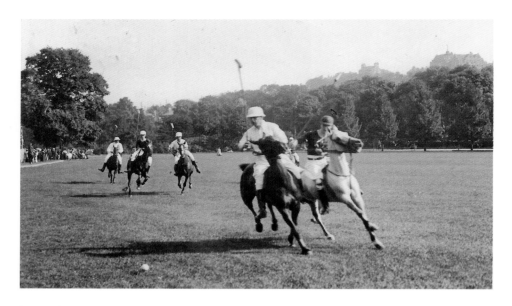

'A Crackerjack Chukka'; Polo in Preston Park

The XXth Hussars of Preston Barracks at a match in 1907. From 1874 The International Gun and Polo Club had a ground where the cricket ground is now. After 1887, the park was used by regiments at Preston Barracks for weekday polo practice and their Regimental Bands would attend and entertain spectators. In the 1920s and 1930s in particular the matches were particularly popular. The Horse Show was another equestrian fixture in the park until removed to Withdean Stadium in the mid-1950s. Otherwise this same area between the Pavilion and the Drive was the scene of football, parades, Hospital Fun Days and a myriad other events. On Sundays, chairs would be set out up by the Pavilion and the Tramways band would entertain. The polo field was delineated by a foot-high wooden edging. It was a favourite game of Joan Beeson and other local children to 'walk the tightrope' along this.

Preston Park in Wartime

In 1940 a family group relaxes near The Ride. The recently constructed Park Court may be seen in the background. Much of the upper park eventually became allotments during the war and a photograph survives showing it bosky with runner beans. The lower was used by the military with soldiers billeted in the mansions of Preston Road and elsewhere. Locals and visitors still gladly used what remained. The second photograph showing society hairdresser Dorothea Tearreau on a visit to Preston is dated 10 July 1941. No allotments yet appear. The wonderfully thick shrubberies of the cricket ground's slopes appear in the background. These hid a circular gun emplacement on the western slope and, until their despoliation in the 1970s, always afforded children a marvellous place to play jungle hide and seek, while keeping an eye open for the uniformed park keepers, who ranked only second to the police in having to be obeyed.

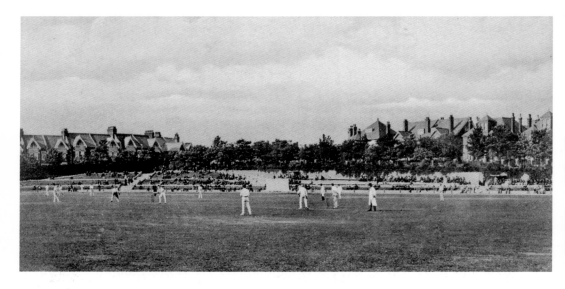

The Thwack of Leather on Willow

The cricket ground and attached cycle track (today's velodrome) were constructed in the walled area formerly used by The International Gun and Polo Club. It opened on 12 May 1887. Before the grandstand was erected in 1930, spectators sat on the banks and terraces on the east side that 'added much to the picturesqueness of the ground' or mounted and in carriages on the southern side. It became the favoured meeting place for Brighton clubs. Pitches were allotted annually to the leading local clubs most of which were affiliated to the Preston Park Cricket Association. The great enthusiasm for bicycle racing in late Victorian times resulted in the laying of the cinder track and races were well attended especially on bank holidays. Cinders gave way to tarmac in 1936. In the 1940s and 1950s there was a great resurgence of interest and between 3,000 to 8,000 spectators attended major events.

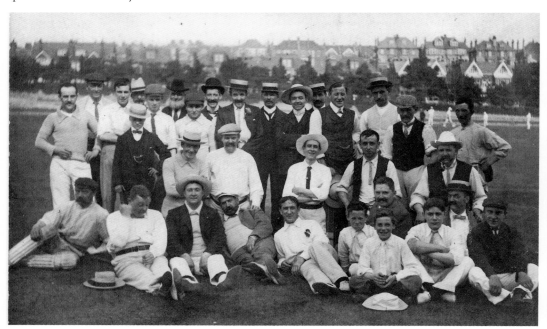

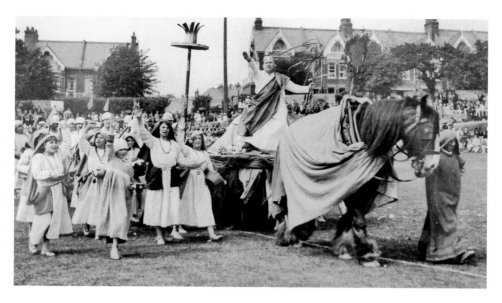

An Emperor Visits Preston Park; Greater Brighton Celebrations, 1928

The triumph of Decimus Clodius Albinus, the Roman Governor of Britain, who was proclaimed emperor here and ruled until killed by his rival Septimius Severus. History does not record a visit to Brighton, however! In 1928 Brighton expanded its boundaries to encompass the area from Patcham to Rottingdean and the town enjoyed a series of celebrations including a Royal visit. Preston Park's cricket ground provided the setting for a pageant featuring a thousand players depicting scenes from Brighton's history. The first of five performances over three days was given on 29 May 1928. The performance area was limited to the north-eastern corner with the spectators in deckchairs and wooden seating on the terraces and grassed lunettes. A Pathé News film survives showing snippets from some of the eight historical episodes. Its cameraman appears by the screens in the lower photograph depicting the (spurious) coming of Anne of Cleves to Preston.

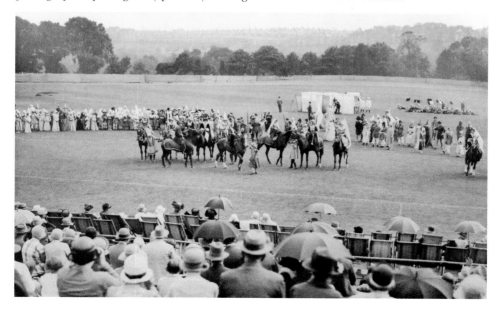

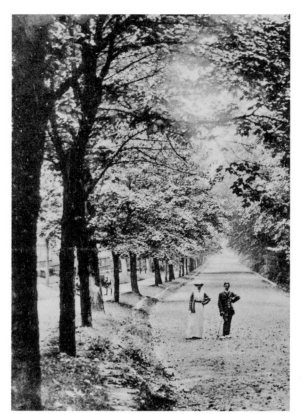

'A Certain Romantic Charm About the Shady Avenue', 1907

Once called 'Stoney Road' locally on account of its flinty surface, The Ride ran parallel with Preston Park Avenue, and was Brighton's inland answer to London's Rotten Row. Originally, a promenade ran between the trees of its grass bank and the railings that were removed in 1936. The gate piers, albeit minus their gates and railings, still remain at the Preston Drove entrance. Neglected runs of the park's original railings fortunately survive near the grandstand. Those at the gate are 1950s and erected to hold a notice board. Equestrians leaving by these gates would originally have been in the countryside. The shrubberies of the section of Lovers' Walk bordering the cricket ground appear to the right. The 1885 engraving shows the southern end of Lovers' Walk and the adjoining and parallel Ride. Blasted by the 1987 hurricane and with its recycling bins and tarmacadam surface, The Ride has lost much of its former charm.